DRAWING BASICS AND BEYOND

DRAWING BASICS AND BEYOND

TRANSFORM OBSERVATION INTO IMAGINATION

SORIE KIM

ROCKPORT

Quarto.com

© 2024 Quarto Publishing Group USA Inc.
Text, Photos, Illustrations © 2024 Eunsol Kim

First published in 2024 by Rockport Publishers, an imprint of The Quarto Group,
100 Cummings Center, Suite 265-D, Beverly, MA 01915, USA.
T (978) 282-9590 F (978) 283-2742

Rockport Publishers titles are also available at discount for retail, wholesale, promotional, and bulk purchase. For details, contact the Special Sales Manager by email at specialsales@quarto.com or by mail at The Quarto Group, Attn: Special Sales Manager, 100 Cummings Center, Suite 265-D, Beverly, MA 01915, USA.

10 9 8 7 6 5 4 3 2 1

ISBN: 978-0-7603-8527-2

Digital edition published in 2024
eISBN: 978-0-7603-8528-9

Library of Congress Cataloging-in-Publication Data

Names: Kim, Sorie, author.
Title: Drawing basics and beyond : transform observation into imagination /
 Sorie Kim.
Description: Beverly, MA : Rockport, 2024. | Series: Sketchbook master
 class | Includes index. | Summary: "Sketchbook Master Class provides the
 tools, techniques, and inspiration artists need to improve their
 sketchbook practice and use the information they gather to create
 imaginative artwork"-- Provided by publisher.
Identifiers: LCCN 2023050490 | ISBN 9780760385272 (trade paperback) | ISBN
 9780760385289 (ebook)
Subjects: LCSH: Drawing--Technique.
Classification: LCC NC730 .K56 2024 | DDC 741.2--dc23/eng/20231122
LC record available at https://lccn.loc.gov/2023050490

Interior Design and Layout: Laura Klynstra

Printed in China

This book is
dedicated to my mom.

엄마 사랑해요!

CONTENTS

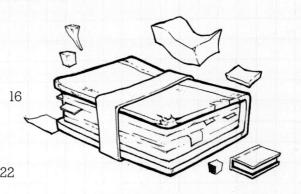

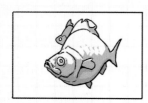

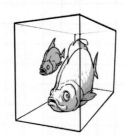

ELEMENTS OF SKETCHING

BASIC FORMS

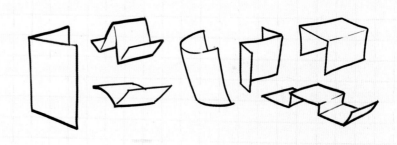

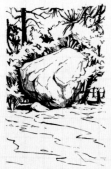
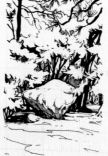
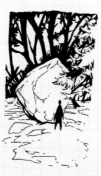

SKETCHING ON LOCATION

ANATOMY OF A SKETCHBOOK

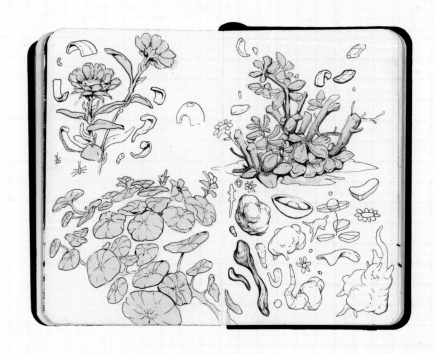

BEYOND OBSERVATION

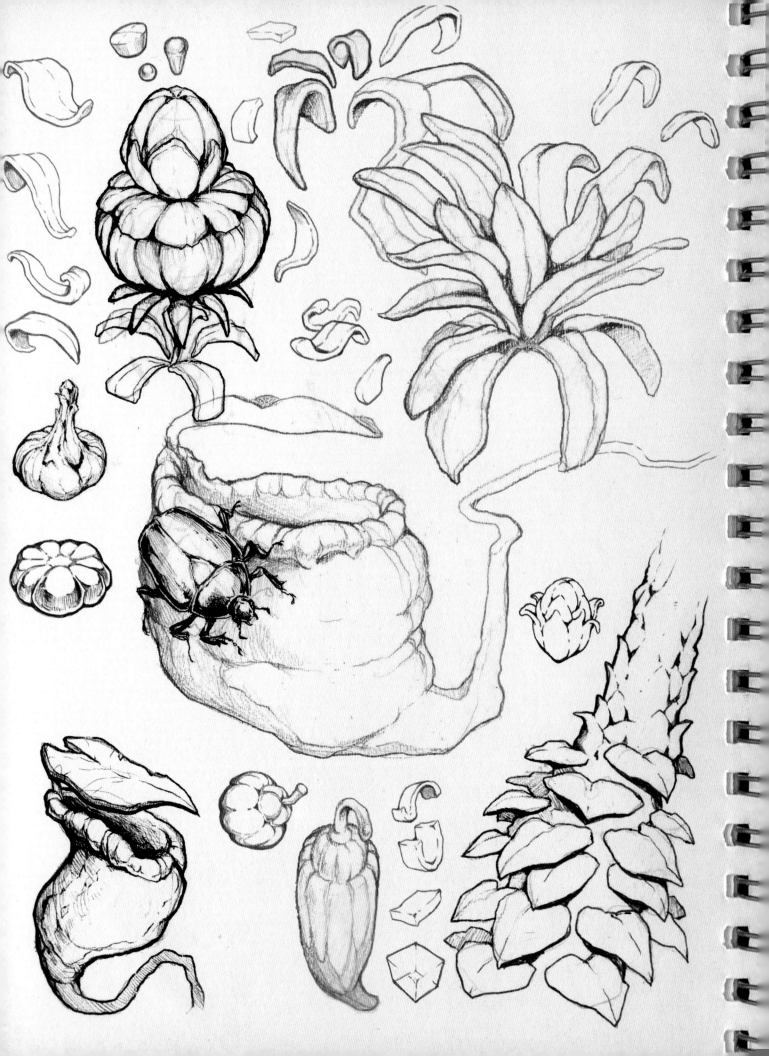

INTRODUCTION

Sketching has always been my favorite thing to do, and I'm so grateful I get to share my process with you here. This book is a practical guide to working in your sketchbook. We will cover sketching basics, the process of sketching on location, and ideas for adding imagination to sketches, and then go through some pages in my personal sketchbooks.

Before we start, here are a couple of things to keep in mind: Everyone learns differently. What works for me may not work for you, so take any advice in this book with a grain of salt. There is no singular or correct way to draw; it's essential to find what works best for you. I'm still learning, and I can only share my limited perspective. Even if I were able to distill everything I know into this book, it would still be only a fraction of all that is out there to learn. Use this as a starting point to explore your own process.

Last, for those of you who are just starting to draw, I'm so excited for you. Please don't feel like you have to learn as fast as you can or become the best artist in the world. Take your time, don't take it too seriously, and enjoy the process. I'm so curious what you'll like and what you'll create. I hope you fall in love with sketching.

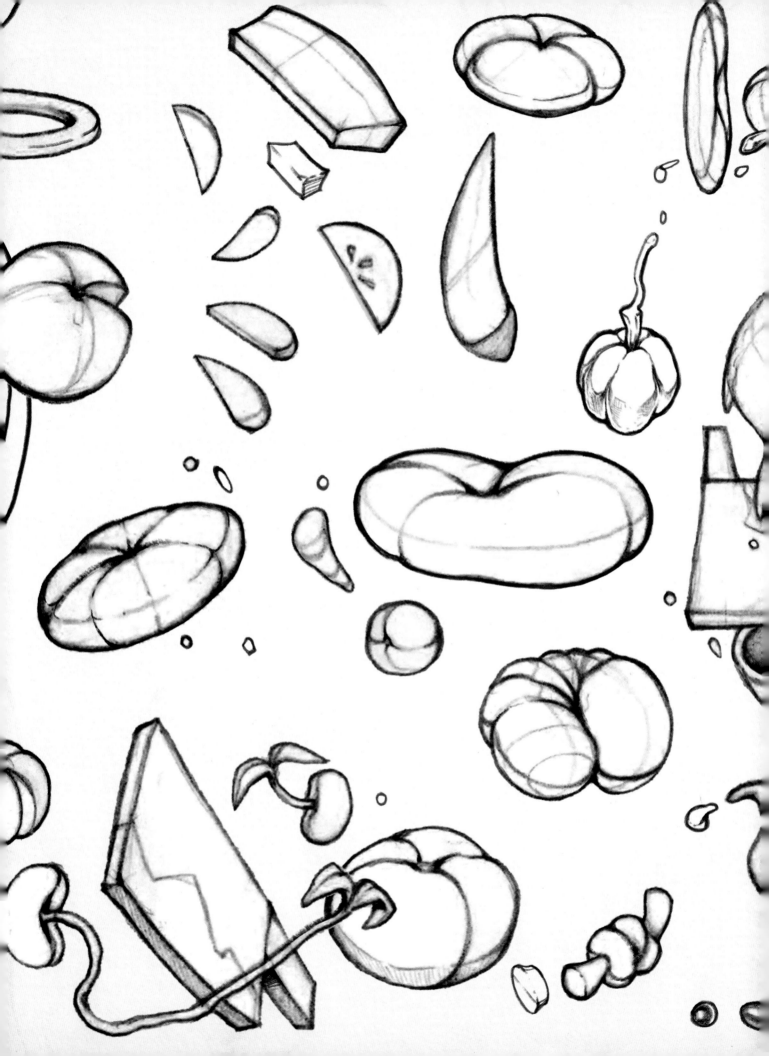

GETTING STARTED

WHY SKETCH?

Think of the sketchbook as a sandbox where you can play, experiment, and make a mess.

It's a space that allows you to explore different processes, take your thoughts in different directions, make mistakes, and push boundaries. For career creatives, a sketchbook could be a place to have fun and explore personal projects and ideas outside of work.

Sketchbooks don't have to look a certain way. Some artists include many loose sketches and notes, while others create sketches that look like finished illustrations. A sketchbook can also serve as a source of inspiration and point of reference for future work. Scribbles and rough ideas can be revisited and developed into finished pieces or used as starting points for further exploration and experimentation. A sketchbook is also where we can work on building up our foundational skills and establish sketching as a daily or routine practice.

Sketchbooks aren't just for professional artists; they can be used by anyone looking for a creative outlet or a way to express their thoughts and ideas. People from all walks of life can benefit from keeping a sketchbook. It's just a space you can make your own: to jot down notes, brainstorm, or explore your imagination.

Basically, it's up to you. There are no rules, and you make your sketchbook what you want or need it to be. If you aren't sure where to begin, I hope this book can give you some ideas on different ways to approach sketching.

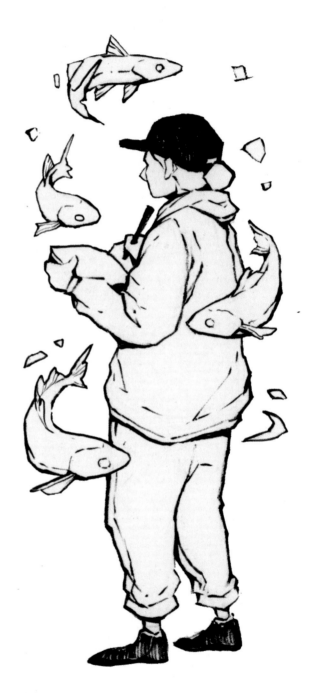

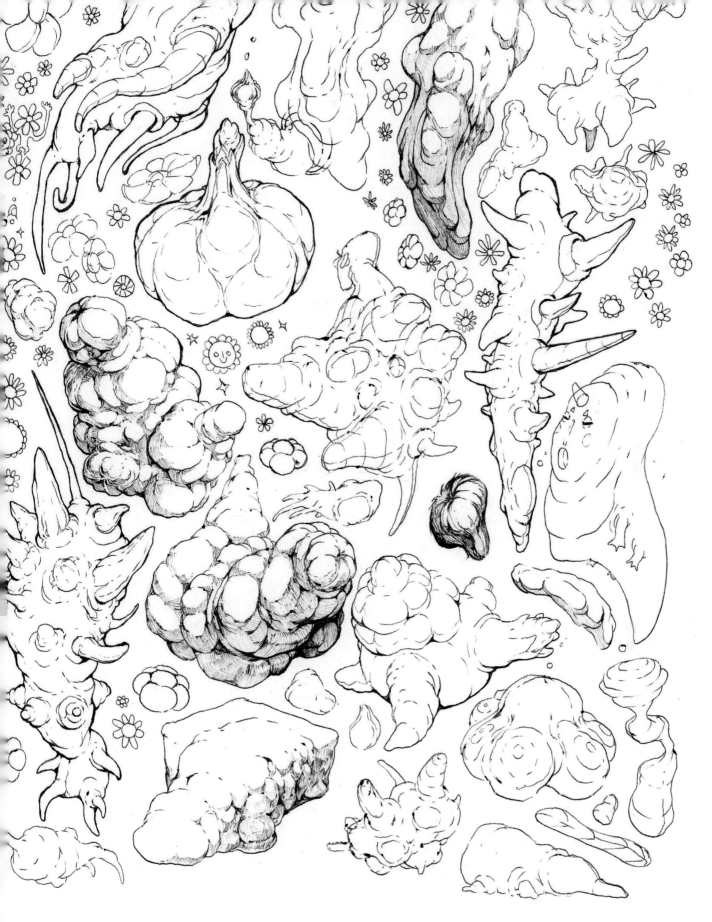

Here is a page of doodles from imagination, focusing on form and volume.

MY APPROACH TO SKETCHING

In this book, I'll be mainly focusing on *representational drawing* from *direct observation*. Representational drawing means we're aiming to accurately depict real-life objects or scenes. The goal is to depict the likeness of the subject in our drawing. Sketching from direct observation means creating a sketch by closely observing and studying a subject in real life, rather than from a photograph or another source. This process pushes us to actively engage with our environment to notice the details and nuances of what we see.

Put simply, I go to a location, draw what I see, and try my best to make the drawing resemble what I see. This kind of sketching allows us to build technical skills and practice the fundamentals of sketching.

WHY I LIKE SKETCHING ON LOCATION

There are many reasons why I love sketching on location.

* Because it's fun. It feels like I'm playing a game. Whether I'm drawing something that I've never drawn before, or something I've done a hundred times, it feels like a new puzzle that I get to solve.

* The parameters. I like that when I draw on location I'm limited to the place, time, and whatever materials I brought. It forces me to loosen the grip on perfectionism, and I find it's easier to just have fun.

* It gets me out of the house. Since most of my work is from home, I find it easy to get into a habit of sitting at my desk all day. Observational sketching helps me get out of the house, even if it's just a walk around the neighborhood.

* It's like a visual journal. Sketching from direct observation over time naturally becomes a log of your life. It's a different way to collect memories and engage with your surroundings.

* It can feel meditative, especially in nature. I have a hard time staying present sometimes, but whenever I get to sketch outside it feels really grounding.

* The world is interesting. There is a never-ending stream of data and inspiration in the world. You could draw the same subject for more than a year and still find new ways to engage with it. The more you draw from life, the more you'll start noticing all the interesting things around you.

* To study. I've just started learning animation this year, and it feels like I'm learning how to draw all over again. Going back to the basics and doing a lot of observational sketching has been extremely helpful.

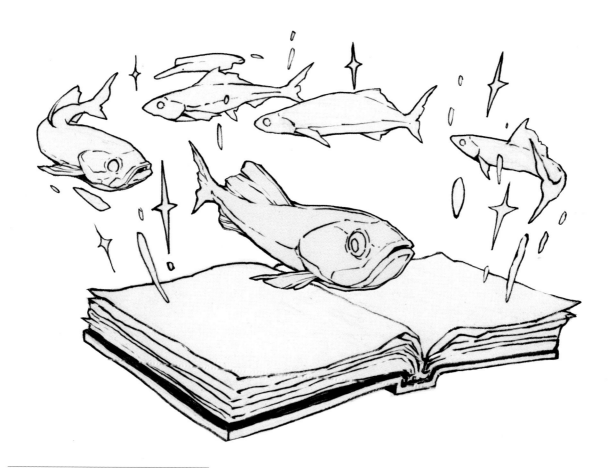

Here is an example of a sketch mixing observation and imagination.

A COUPLE OF THINGS
TO REMEMBER

Even when the intention is to work on fundamentals, the point isn't to make a perfect drawing or sketch. Our focus is on the learning process, or the act of drawing itself. Think of your drawing as just a souvenir from the experience that you get to keep.

What is shown in this book isn't the only way you should draw or use your sketchbooks. I encourage you to experiment outside of all the approaches and techniques shown here.

This spread was drawn from imagination after many studies from reference. When I sketch from observation or reference, the aim is to get to a point where I understand the form completely.

RIGHT: This page of doodles is from imagination, but I'm sourcing the forms and patterns from nature.

IN MY PENCIL CASE

I currently use a metal tin by Derwent to store my supplies. It won't stay closed anymore, so it's held together by a massive rubber band. It has a middle compartment for added storage that can also be used as a palette.

BALLPOINT PENS

I think of ballpoints as a hybrid between graphite and ink. Although ballpoint pen is a permanent medium, it allows you to gradually build up **opacity** (indicates the transparency of the medium) like a pencil and gives you access to a full range of **values** (how light or dark something is). It also allows for really thin, delicate lines.

PILOT COLOR ENO MECHANICAL PENCILS

I don't like graphite right now, so I use these mechanical colored pencils instead. These are erasable if you sketch lightly enough, but I also love the look of the color layered under ink or on top of gesso. I'm trying to become more gestural and loose as I sketch, so these have been fun to scribble with.

FELT-TIP PENS

The ones I use the most are the Faber-Castell Pitt Artist Pens and Pentel Stylo Sketch Pens. These pens have a static line weight and are also permanent mediums. Because of these constraints, they're actually great pens to begin sketching with. Every mark you put down has to be intentional, and line weight and values all have to be manually built up. It forces you to think about each decision you make and let go of mistakes.

BRUSH PEN

Brush pens are some of my favorite tools to use. They may take some time to get used to, but I think it's well worth the effort. These pens allow you to control not only line weight but texture and opacity as well. Look for brush pens that have an inkwell that allows you to control the amount of ink. If you allow the pens to dry out, you can achieve some beautiful textures.

MARKERS

The ones I have right now are from Zig and Faber-Castell. These are water-soluble pens that diffuse like watercolor when mixed with water. I love blocking out big shapes with one of these to carve in two-value studies. I also keep a regular yellow highlighter in my case.

ERASERS

I carry a regular plastic eraser and a pencil-shaped eraser that I can sharpen to carve out details.

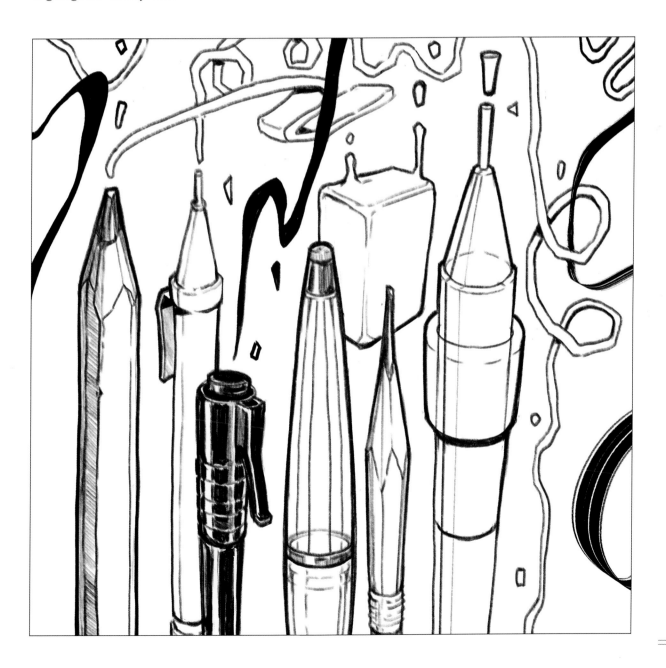

MY SKETCHBOOKS

These are the sketchbooks that I currently use, with some details of the different formats. Remember that you don't need these specific brands, and you don't have to have multiple sketchbooks going at once. Depending on your objectives and creative process, your needs will be unique.

MAIN SKETCHBOOK

This pocket-size Moleskine is the main catchall for my sketches. The size makes it easy to carry in most bags, and the paper receives most mediums well, even some paints. This sketchbook acts almost like a visual journal for me, as I use it to draw from direct observation. It is 3.5″ x 5.5″ (9 x 14 cm) and contains seventy-two pages of 120-gsm acid-free paper.

UGLY SKETCHBOOK

I used to really struggle with perfectionism in my sketchbooks, but I also love rendering or adding detail and values, so I tend to get lost in that aspect of sketching. By designating a cheap sketchbook from the dollar store as a space for "ugly" sketches, it helps me get out of my head and experiment outside of my comfort zone. This practice 100 percent changed the way I sketch.

WATERCOLOR SKETCHBOOK

I use a Moleskine watercolor book for gouache, watercolor, and markers–any medium that a regular sketchbook can't hold. It has cold-pressed, cotton-blend paper and can handle paint on both sides without bleeding through or warping too much. The one I use is 3.5″ x 5.5″ (9 x 14 cm) with 72 pages of 200-gsm, acid-free paper.

TRAVELERS NOTEBOOK

As the name suggests, a travelers notebook is a really fun option to travel with. It allows you to switch out books of different kinds of paper, such as grid, watercolor, and regular drawing paper. The books are held together by a rubber string in the center. I also keep a small zipper pouch in mine to store little scraps of paper, receipts, and the like that I pick up. The watercolor sketchbooks for the travelers notebook only have about thirty pages, so I try to dedicate one book per trip.

TRAINING SKETCHBOOK

This 8.5″ x 11″ (22 x 28 cm) sketchbook is the biggest I use, and it comes from Artist's Loft. I use it for warm-ups, studies, and demos. These are affordably priced and the 110-gsm paper holds even gouache and watercolor to an extent. The binding of these sketchbooks does come off easily, but it can be quickly mended with duct tape or bookbinding tape.

DIGITAL SKETCHBOOK

Digital sketching is like having access to every medium at once. I use Procreate on an iPad Pro. The software is pretty intuitive, and it records your sketches as well. I've been trying to paint more en plein air recently, and digital sketching is handy when I don't want to carry physical paints and brushes.

STACK OF PAPER

If you have a habit of tearing out pages, this might be a great option for you. I have a clipboard that opens up to store a variety of papers. I use this often for demos, for bigger sketches, and when I need more polished drawings.

THE FUNDAMENTALS OF SKETCHING

In the next couple of chapters, we will take a close look at the basic skills and principles, which are helpful to understand as you grow in your sketching practice.

WHAT ARE THEY?

The fundamentals of sketching are the basic principles and techniques that serve as the foundation for sketching. They are the building blocks of drawing. Understanding principles such as perspective, form, rendering, and composition will be helpful in creating sketches that accurately depict the subject matter. If you're new to sketching, it can be overwhelming to think about all these components at once. Isolating one principle of sketching (e.g., perspective) can be a great way to practice and build your understanding of the fundamentals. We will go through some exercises in the upcoming pages.

WHY DO WE NEED THEM?

Building up your technical skills gives you freedom. Before you write music, you need to learn how to play your instrument and how to play the notes. Ultimately, the goal is to learn the fundamentals of sketching so you don't need to focus so heavily on them. Understanding the basics allows you to let go and engage in designing, storytelling, or just drawing whatever you want.

Technically advanced art isn't the peak, but the more you learn, the more range you have to say what you want exactly the way you want to say it. Building technical skills also gives you a direction and reference point to start with when learning to draw.

That being said, you don't need to fixate on this part. You don't need to master technical skills before creating what you want.

This isn't an exhaustive guide by any means, so I encourage you to dive deeper into each topic with more research and practice.

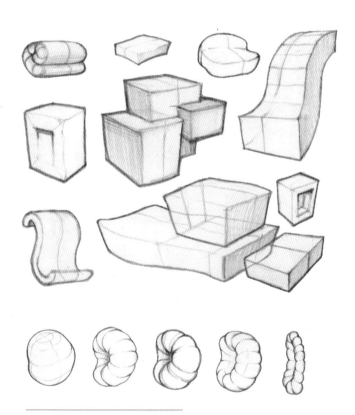

Understanding the basic principles and techniques of sketching will allow you freedom to manipulate shapes and objects in your drawings and create anything you can imagine!

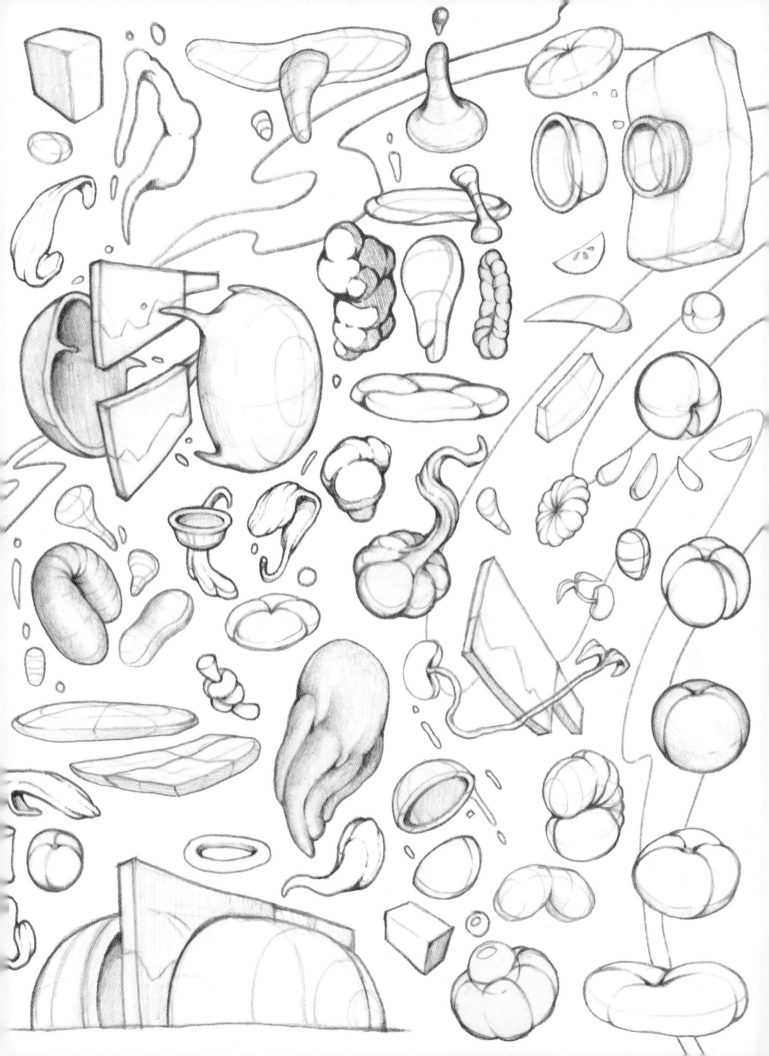

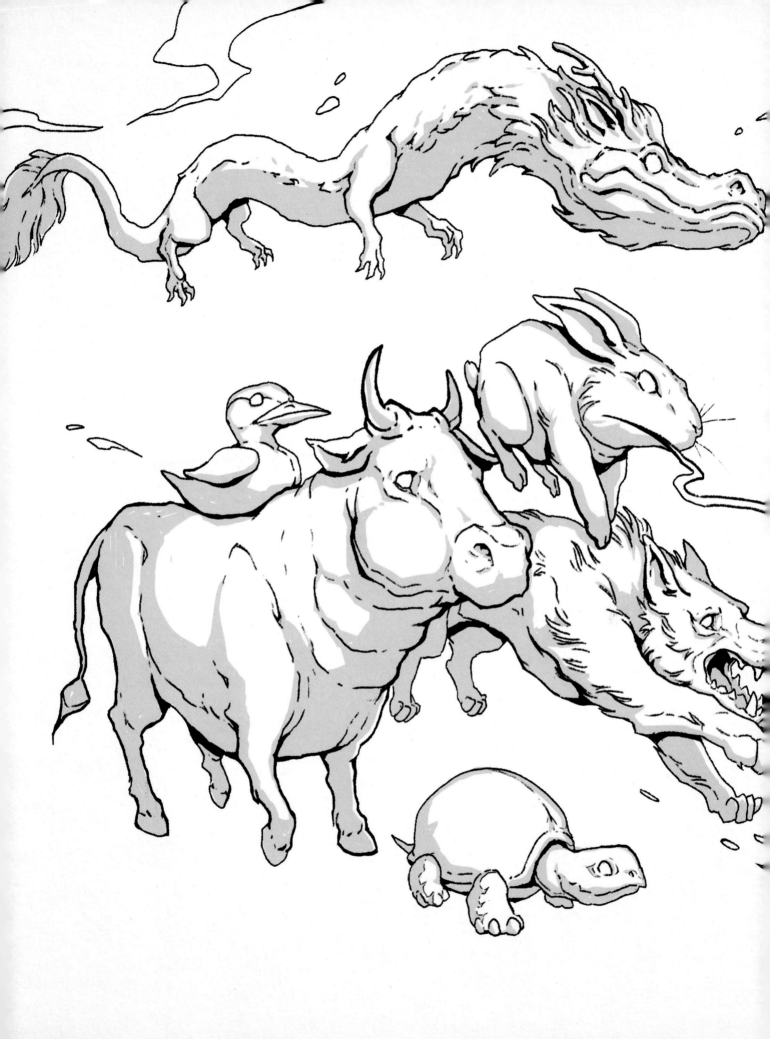

ELEMENTS OF SKETCHING

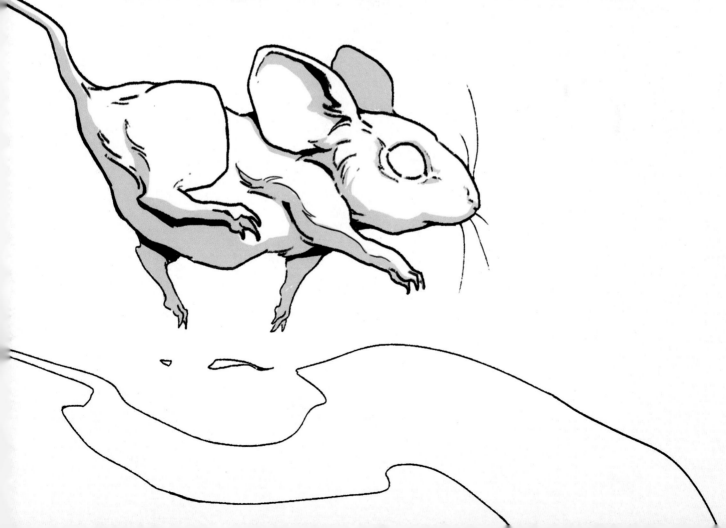

THE EIGHT ELEMENTS OF SKETCHING

These are eight elements of sketching that can be useful to learn. Each of them plays an important role in creating dynamic and grounded drawings. Don't be intimidated, however—these won't come into play with every single sketch you make, nor do you have to think about addressing all eight elements every single time you sketch. We'll go through each one in detail in this chapter.

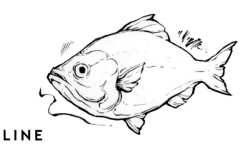

LINE

Line is the base ingredient of sketching. We use line to construct and define our subjects; and to convey texture, movement, and depth. Line weight can create visual interest, weight, and contrast. The quality and type of linework used can affect the overall look and feel of your drawing.

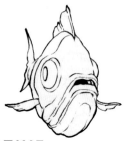

PERSPECTIVE

Perspective is what creates the illusion of three-dimensional space on a two-dimensional surface. Think about taking a camera and shooting your subject from different angles. Perspective allows you to choose how you frame your subject.

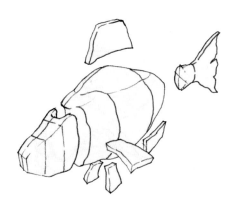

VOLUME AND FORM

In drawing, form will convey the dimension of a subject and give it volume. Focusing on form helps to create a sense of depth and solidity. Form can be conveyed through a variety of ways, such as the use of contour lines (see page 30) or rendering.

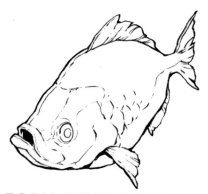

FORM SENSITIVITY

Once you have established basic forms and perspective, the next step is to add form sensitivity (see page 34). We can build up form sensitivity by carving out more and more planes to achieve more intricate and complex forms. This will make your sketch appear more grounded and realistic.

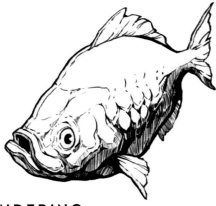

RENDERING

Rendering is the process of adding values and further carving into your subject. By paying attention to the details and characteristics of the objects or subjects being depicted, you can create a highly convincing and lifelike representation of them. Rendering can be used to show the physical properties of objects, such as the material or texture.

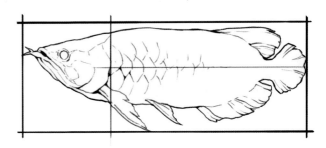

PROPORTION

Certain subjects, such as humans, animals, and manmade objects, have fixed proportions. Learning accurate proportions, shapes, and components of your subjects creates a sense of realism and believability, but remember that you can always manipulate these proportions later on.

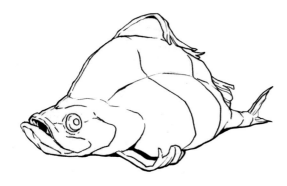

MOVEMENT AND WEIGHT

Often when we focus on basic forms and construction, the sketches can turn out a bit stiff. Introducing weight and movement in your sketches can bring a lot of life and energy to your sketches.

DESIGN

We can still think about design even as we're sketching a subject from life. Designing something involves making intentional choices about how we portray or interpret the subject. We can utilize elements of design to convey a feeling, or to emphasize certain forms in our sketches.

LINE

Being able to execute clean, confident lines will bring a lot more clarity into your sketches. I think the best thing you can do to develop better line control and confidence is to just draw a lot. It will naturally come with time.

That being said, if you would like to practice, especially if you're new to drawing, here are some exercises. I would recommend a pen with a static line weight (such as a fineliner) for these exercises. I'm using a Faber-Castell 0.3 mm pen.

CONNECTING DOTS

Plot two points first and connect them in a straight line. Be mindful of the quality of your lines and the pace that you move your hand. Find a tempo that is comfortable.

If you find that your line is too jittery, you may be moving your pen too slowly.

If your line is getting wispy toward the end, you may be moving your pen too fast.

Try to find a nice tempo that creates clean, confident lines.

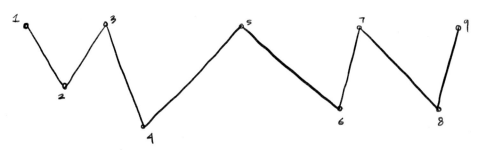

After you practice connecting two dots, try connecting multiple dots in a zigzag line. This will help you get comfortable changing direction.

HATCHING

Hatching is a wonderful technique for rendering and mark-making, particularly with ink. You can draw hatch lines in any direction and also draw them on top of each other in different directions to create density.

Create some thumbnails and practice hatching in different directions and frequencies (distances). Try to keep the lines equally spaced from each other.

You can also practice hatching outside of boxes, which does not have to be as rigid.

LINE WEIGHT

Line weight, or line quality, refers to the thickness of the line. By manipulating the weight of your lines, you can create depict depth and add subtle variation to your drawings.

Create a thin line with a static line weight. It can be any length you'd like.

Go in and manually build varied line weights at different points of the line. If you're working digitally, try out different variations on the same line and see how each version reads.

VOLUME AND FORM

Volume and form help show the dimension of the subject. This is what brings the illusion of three dimensions to our two-dimensional sketches. Mastering form, volume, and perspective will give you the freedom to sketch freely and build from your imagination.

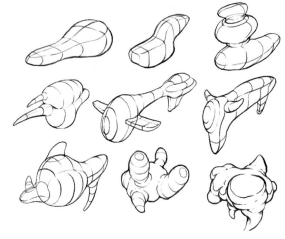

CONTOUR LINES

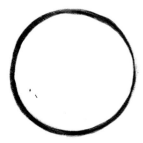

To begin, let's say you have a circular ball of clay.

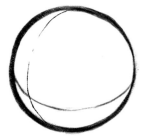

If you were to draw a line or two (contour lines, lines that describe the volume of a form) wrapping around the circumference, it would look something like this. Notice how suddenly the form has become clearer. The contour lines are describing the volume of the subject, creating the illusion of three dimensions.

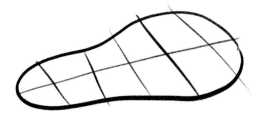

Straight lines can flatten out a form.

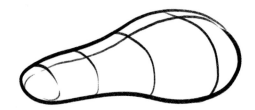

Curved lines can give it more volume.

CHANGING VOLUME

The volume you assign to a shape is arbitrary. We could take the same silhouette or shape and assign it different kinds of volume by sketching different contour lines through it. For example, we have this ovular shape. I'm going to use contour lines to create three different examples of volume. Notice what the contours say about the form, while the silhouette remains the same.

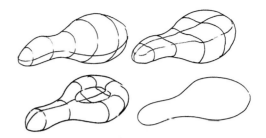

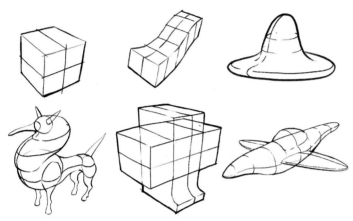

This isn't limited to organic blobs. We can use contour lines to indicate volume on any subject—simple or complex. Think about building a topographical map on a surface.

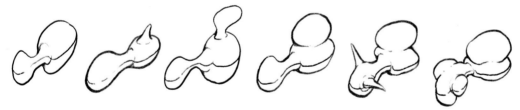

We don't have to show an entire grid on our subjects to effectively describe form. It can be as simple as just showing the X- and Y-axes or the center line on the form.

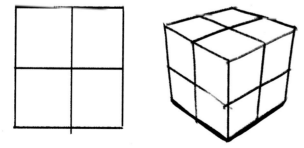

For example, if we were to look at this box from a bird's-eye view, we might see the X- and Y-axes looking like flat perpendicular lines. As we change the camera angle and look at this box from an angle, we can see how the center line shifts with the perspective.

PERSPECTIVE

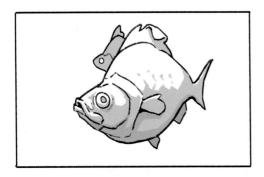

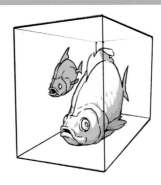

Perspective introduces depth and space into a sketch. Here we have an aquarium with some fish inside. If we look at the aquarium from the side, it may look like this.

If I rotate the aquarium to make a more dynamic perspective, it might look like this. Notice how the fish closer to you seems bigger. Even in the fish closest to you, the head is much larger and the tail tapers. As the fish recedes into space, it gets smaller and smaller.

HOW TO ESTABLISH PERSPECTIVE

To establish perspective grids in a drawing, start by defining your horizon line. The horizon line is the viewer's eye level and the point where the sky appears to meet the ground. It is used as a reference point for for placing objects within a space.

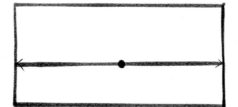

Place one or more vanishing points on the horizon line depending on the desired perspective. Here I placed one vanishing point for one-point perspective. The vanishing point is a specific point on the horizon line where the perspective lines will converge to a point.

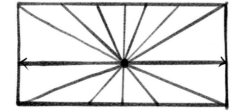

Draw lines radiating from the vanishing points, creating a grid. Use this grid as a guide to accurately depict objects in the chosen perspective, ensuring a consistent sense of depth and scale throughout the composition. Let's take a look at different kinds of perspective.

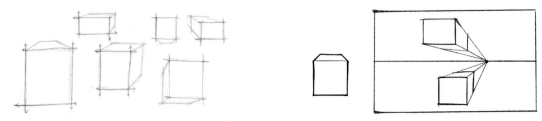

ONE-POINT PERSPECTIVE

One-point perspective uses a single vanishing point on the horizon to create depth. It works well for linear objects and interior spaces, giving a sense of distance and scale.

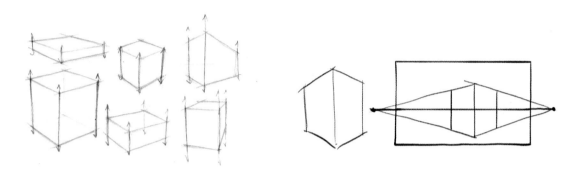

TWO-POINT PERSPECTIVE

Two-point perspective utilizes two vanishing points to create more complex depth and to add more dimension.

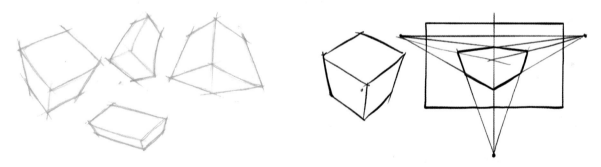

THREE-POINT PERSPECTIVE

Three-point perspective includes a third vanishing point above or below the horizon line for a dynamic view. It is ideal for large-scale scenes and objects with extreme foreshortening, providing an immersive experience.

You don't necessarily need to set up a full perspective grid every time you sketch, and I wouldn't recommend it. Practicing freehanding perspective sacrifices a bit of precision, but I think it's an extremely useful skill to learn.

Start with simple singular subjects and try expanding to include more objects in a shot. When sketching a full scene, it can be helpful to quickly block in some loose lines to establish a rough guide for perspective within the space or to make a tiny thumbnail to get a feel for the space.

FORM SENSITIVITY

Let's talk about adding form sensitivity. Form sensitivity is sculpting further into the basic form to create a more grounded and believable depiction of the subject. The best way I can explain form sensitivity is by comparing low-poly video games from the 1990s (low form sensitivity) to the highly rendered models of today (high form sensitivity). Once we have broken down the subject into basic forms, we can start sculpting or carving into those forms to create more dynamic or grounded sketches.

Studying form sensitivity in reality will help when drawing from imagination—and allow you to bring more realism into your sketches. Here are some exercises that can help improve form sensitivity.

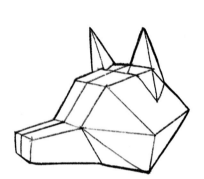 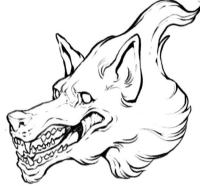

Low form sensitivity (left) and high form sensitivity (right).

OVERSATURATE DETAILS, ELIMINATE PERSPECTIVE

An exercise I really like for practicing form sensitivity is to exaggerate texture and detail 110 percent. It helps to flatten out perspective by choosing a side or front view of the subject, so that you can focus solely on texture and detail.

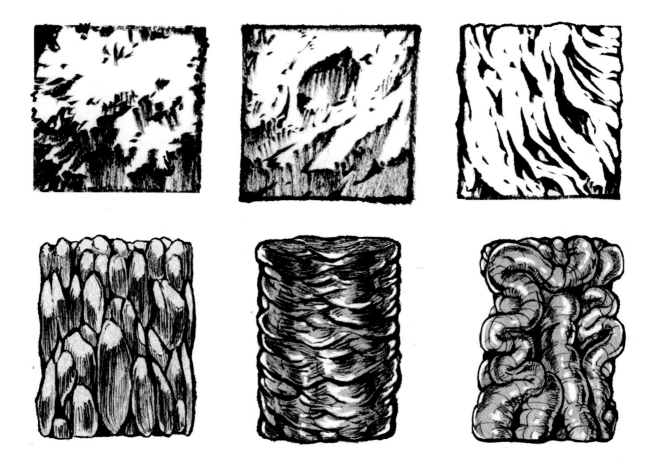

TEXTURE STUDIES

Like the examples above, texture studies are a great way to improve form sensitivity. Pay closer attention to the surface of textured objects and try to re-create the texture in a sketch. As above, it can be helpful to start by flattening the texture out into a thumbnail.

BLIND CONTOURS

Blind contour sketching is a drawing technique designed to improve observation skills and hand-eye coordination. In this exercise, let's focus on the subject's contours and edges, while refraining from looking at the drawing surface. Keep your eye on the subject as much as possible and don't lift your pen off the paper.

Although the resulting sketches may appear unconventional or abstract, the primary goal of the exercise is to train the eye and hand to move together.

RENDERING

Rendering is where we think about light, detail, volume, and texture. It can be a little daunting, so let's begin by taking a look at three basic forms: a box, a cylinder, and a sphere. Because all subjects are made of basic forms, understanding how shadows sit on each of these forms can be very helpful. Notice how the hard edge of the box shows a clean cut of values, while the rounded edges of the cylinder and sphere show more of a gradient.

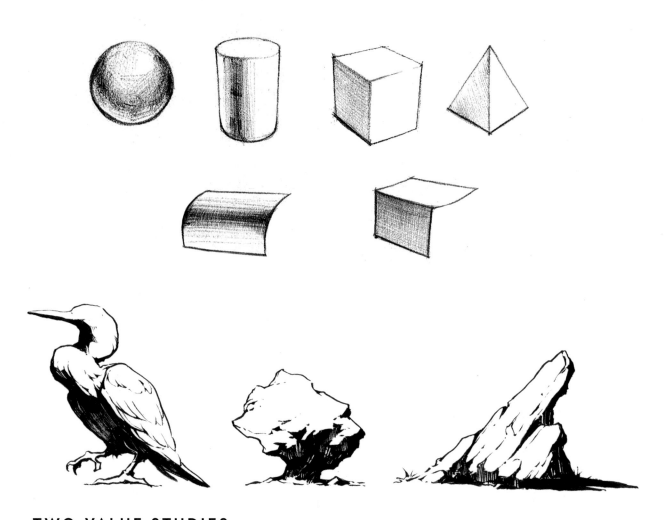

TWO-VALUE STUDIES

A great way to practice rendering is with two-value studies. Let's apply this concept to basic shapes and some more complex subjects. The point of these two-value studies is to simplify values to the highest contrast of light and shadow. Pay attention to the shadow shapes and try to group together the shadows as much as possible. For two-value studies from direct observation, we want to look for direct lighting with high contrast.

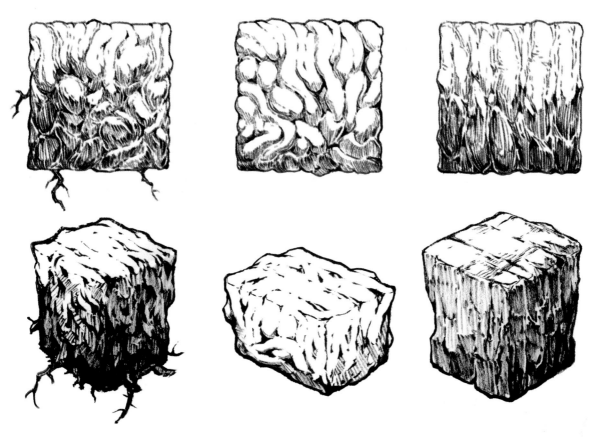

SURFACING EXERCISE

Following the texture studies on page 35, these surfacing exercises are a great way to practice rendering. Pay closer attention to the surface of textured objects and try to re-create the texture in a sketch. As above, it can be helpful to start by flattening the texture out into a thumbnail. Once you get comfortable, try applying the texture to a three-dimensional form.

SIDE VIEWS

As you practice rendering more complex subjects, it can be helpful to begin with side views. Eliminate perspective and form so you can just focus on rendering. Then try rendering the same subject in perspective, while maintaining a similar texture.

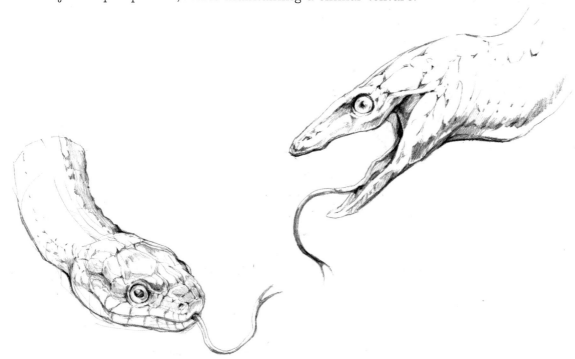

MOVEMENT AND WEIGHT

Introducing movement and weight into your sketches can add a lot of life, energy, and believability to them.

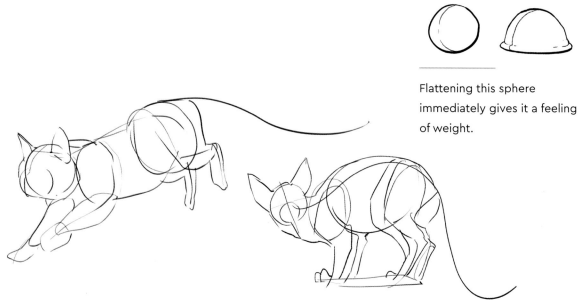

Flattening this sphere immediately gives it a feeling of weight.

GESTURE DRAWING

To practice capturing movement and weight, try gesture drawing. Set a timer for short intervals (for example, 30 seconds to 2 minutes) and quickly capture a moving subject, such as a dancer, athlete, or animal. Focus on capturing the subject's rhythm and motion rather than details. Observe how weight distribution affects the subject's posture and balance.

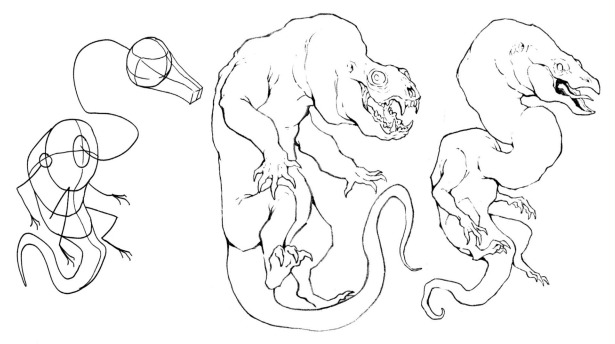

WIREFRAME

Using a wireframe can be a great foundation to build different subjects or characters on top. This allows you to focus on the pose/movement without having to think too much about details. For example, here is a pose with two different creatures applied.

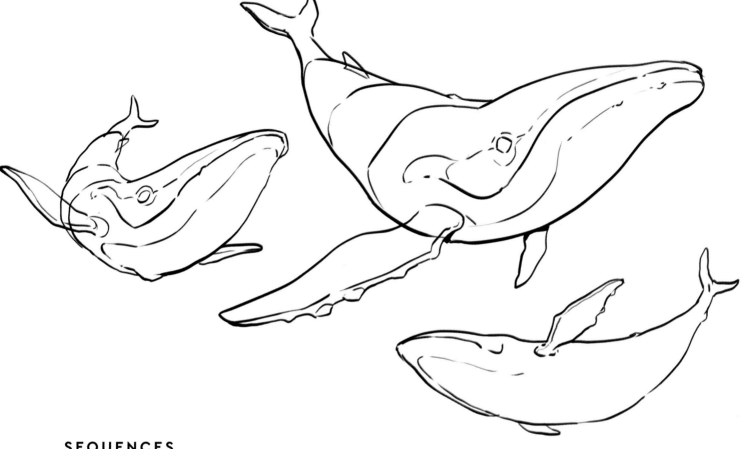

SEQUENCES

We can learn a lot from studying subjects in motion. Find a reference of a subject in motion and break the movement down into a sequence of key frames or stages. Sketch each frame quickly and notice how the forms rotate and change shape.

PROPORTION

Certain subjects, such as animals, humans, and vehicles, have fixed proportions. To be completely honest, I don't think accurate proportions are super important. So much of design is altering or exaggerating proportions anyway. But if we're trying to depict accurate proportions, we can start with side views.

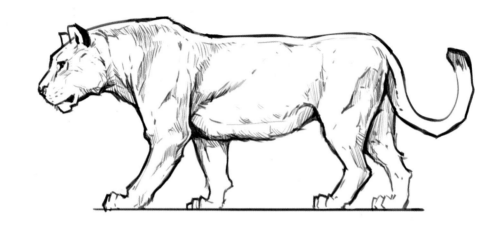

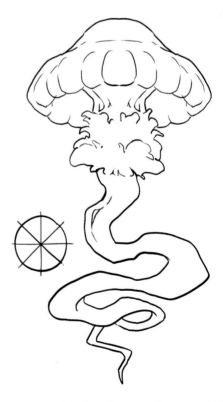

SYMMETRY
Most subjects either have bilateral or rotational symmetry. Rotational symmetry revolves around a fixed central point. When viewed from above, every slice is identical to one another.

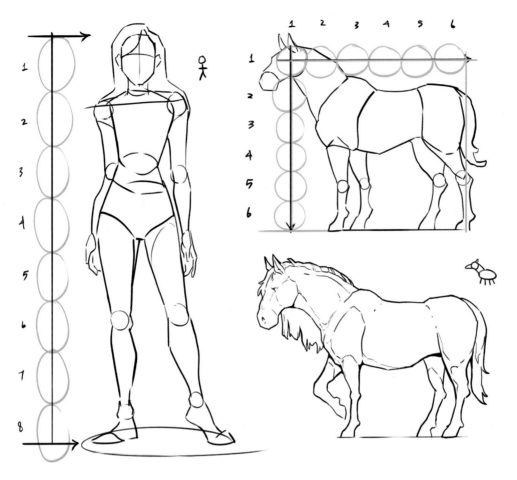

MEASURING PROPORTIONS

When we're able to see all the information on the side or from above the subject, we can get a full read of it to visually measure out proportions. It can be useful to use a piece of the subject, such as the head or a wheel, as a unit of measurement. For example, let's look at these figures. We'll use the head as a unit of measurement. This human figure is about 7 heads tall, and the horse is about 6 heads tall and 6 heads long.

COMPARISONS

It can also be helpful to compare and contrast similar subject matter. For example, what makes a zebra different from a horse or donkey? When we study these similar creatures side by side, it gets easier to identify the idiosyncrasies of each subject.

CARICATURES: PLAYING WITH PROPORTIONS

I find that especially with animals, it's easier to think about defining characteristics than to attempt perfect proportions. There are components or features that we can exaggerate while still retaining the subject's essence.

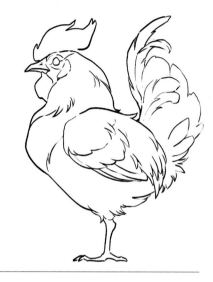

For example, let's look at this rooster.

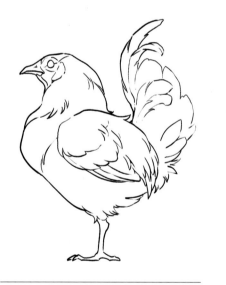 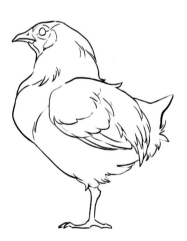 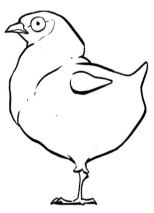

We can take away certain components that would make it less of a rooster, such as the comb, wattle, wings, or tail. At a certain point, the rooster isn't a rooster anymore.

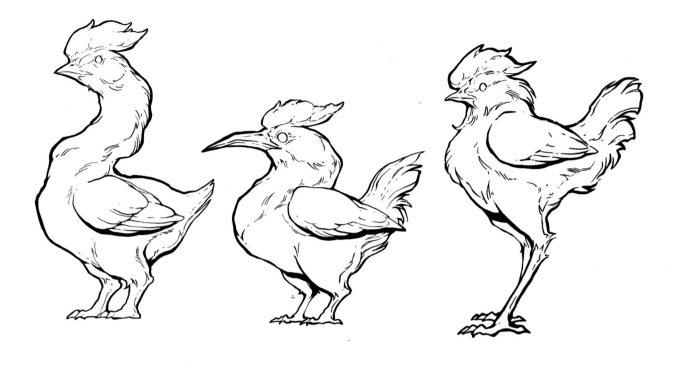

We can do the same thing with a subject's proportions and forms. Let's try changing up the proportions of the neck, legs, or body. Even small changes to recognizable or essential proportions will detract from the likeness.

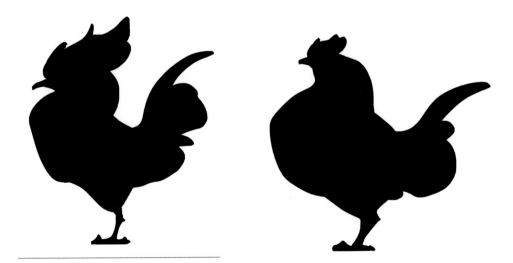

Now let's try leaning into these proportions. Even though the proportions aren't realistic or perfect, the sketch still is a recognizable caricature of the subject.

DESIGN

Even when we're studying from direct observation, we can think about design. You don't need to feel pressured to re-create what you see verbatim; your sketch is an interpretation through your eyes and hands. Think of designing, or stylizing, as all the choices we make when we draw. Think about what you want to push or pull in a sketch. Here are some ways we can practice designing what we see.

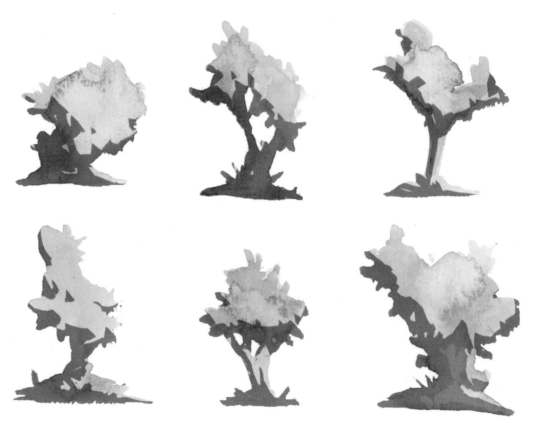

SILHOUETTES

Focus on just the silhouettes of what you see and keep them fairly small. Start reducing the subject to just shapes. On the first thumbnail, I could just try to block in exactly what I see, but on the second, third, etc, I'm pushing the silhouette in different directions. I love sketching organic subjects such as plants, rocks, trees, and foliage, because there is so much information and different directions you can pull toward.

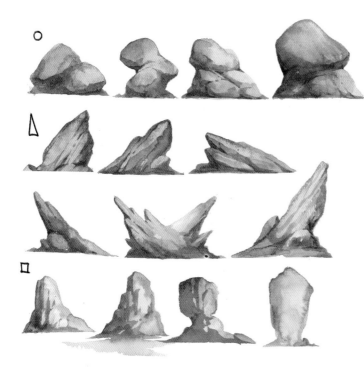

CIRCLES, TRIANGLES, AND SQUARES

This exercise is similar to the silhouette practice on the previous page, but we're focusing on designing the subject with specific shapes that convey ideas or emotions in mind. Here are some rocks that are inspired by circles, triangles, and squares. Notice how the feel of the subject changes with each shape. For example, sharp angles could suggest precision or danger, while rounded shapes may evoke feelings of fluidity, softness, or comfort.

INTRODUCE NARRATIVES

I think an intuitive and fun way to introduce design language to everything we see is to assign a mood or narrative to it.

Let's take these trees as examples. These are just silhouettes, but the tree on the left appears happier than the one on the right.

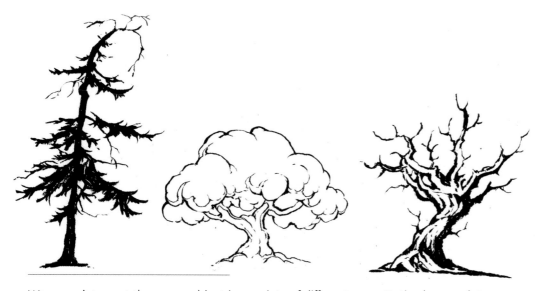

We can reinterpret the same subject in a variety of different ways. Notice how each tree conveys a different tone.

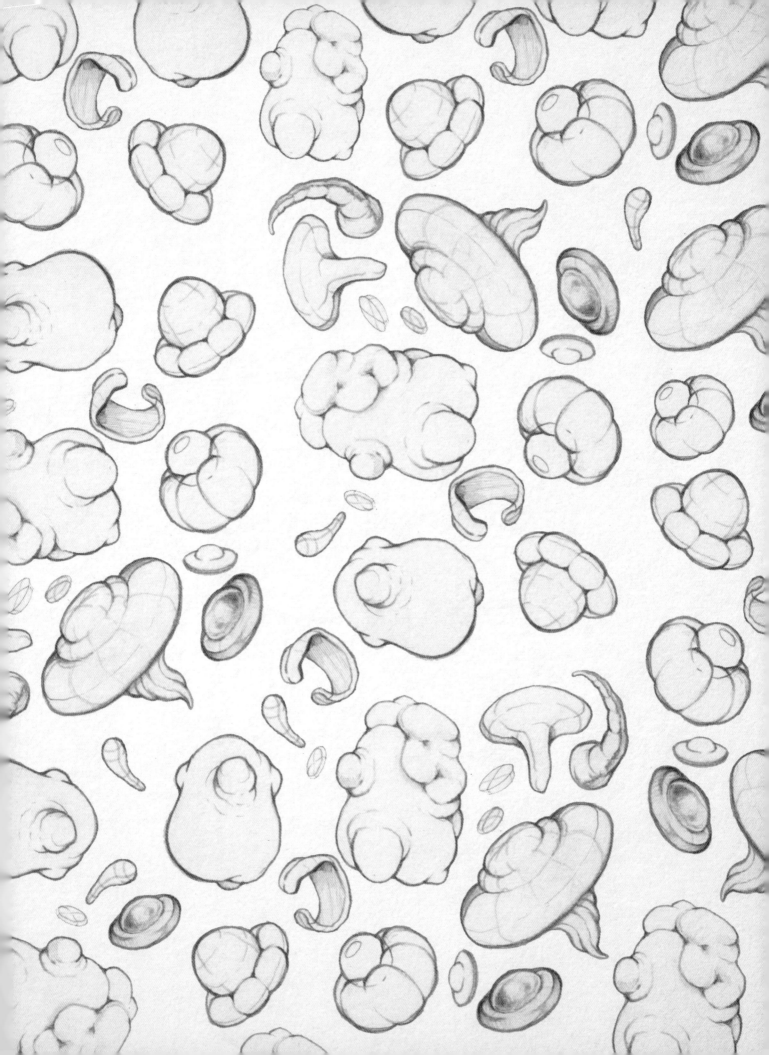

BASIC FORMS

THE SIX BASIC FORMS

These six basic forms and their modifications and combinations make up everything that we draw: planes, boxes, cylinders, spheres, pyramids, and cones. We'll go through them one by one in this chapter, but first we'll look at some principles of working with forms.

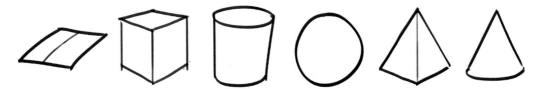

PUTTING THEM TOGETHER

Understanding how to construct and manipulate these six forms helps us to sketch more complex forms. Practicing with these basic forms also helps us think three-dimensionally instead of just in flat images. For example, learning how to draw a box from any angle also helps us sketch more complex subjects in different perspectives. We can also practice modifying and combining the base forms to create more interesting variations. These modifications can be rigid or organic. Remember that these technical skills aren't prerequisites to sketching what you want. Think of them as helpful skills that you learn alongside your creative work that will give you more freedom to make what you want.

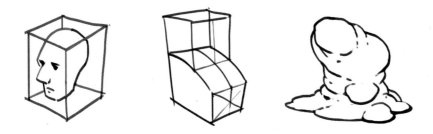

Any object you want to draw is made up of one or more of the basic forms.

SHAPES VS. FORMS

Shapes live in a two-dimensional world, meaning they are flat, like a square or a circle. Forms exist in a three-dimensional world, meaning they have height, width, and depth, like a box or a cylinder. Two-dimensional shapes can be placed in space to create three-dimensional forms. For example, a cube is made up of six different squares, while a cylinder is made up of two circles and a rectangle.

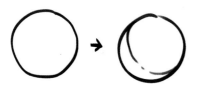 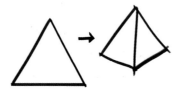 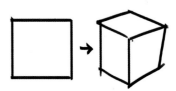

X-, Y-, AND Z-AXES

One of the most useful skills for sketching is understanding how to visualize space and perspective. Every object has three axes, which we call X, Y, and Z. If we look at the sheet of paper below, we can assign a Y-axis in the vertical center. We can also assign an X-axis cutting across the horizontal center.

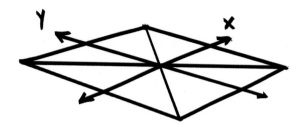

In order to see the Z-axis, let's first place the sheet of paper on an imaginary table. The X- and Y-axes now sit in the same perspective with the paper, flat on the table. The Z-axis runs vertically through the paper at the intersection of X and Y.

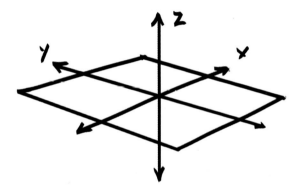

Now if we place the piece of paper upright at an angle, we can see the Z-axis running through the center of the paper.

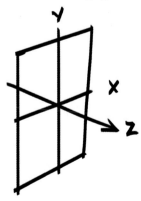

We can start practicing by sketching lines that sit on the X-, Y-, and Z-axes in different combinations and angles. They can be difficult to see at first, so be patient with yourself!

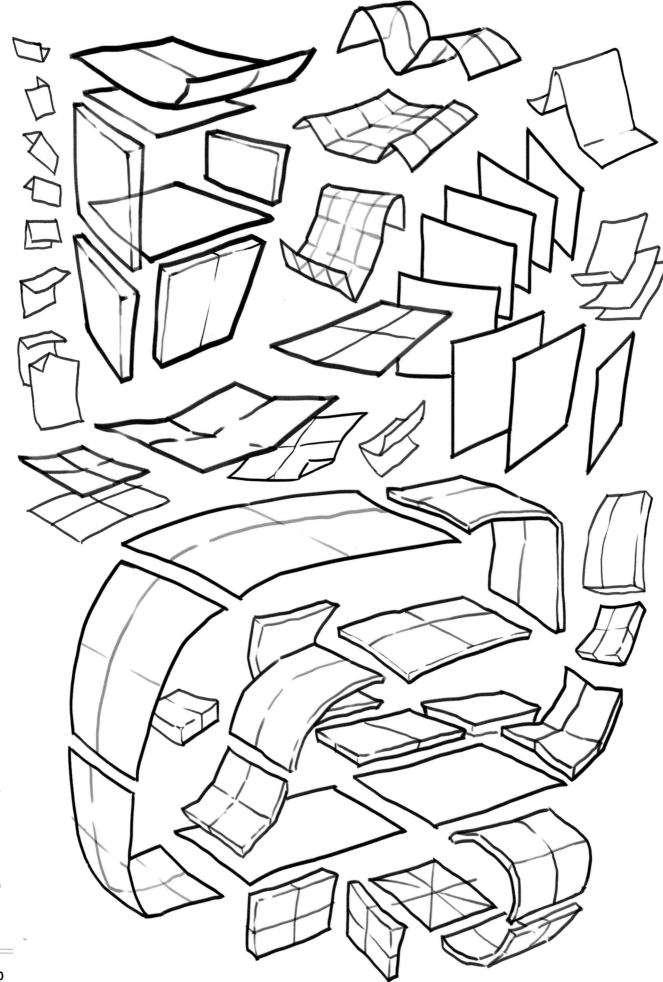

PLANES

Planes are flat surfaces that are used to depict the forms or surfaces of a subject. By adding more planes to a drawing, you can create a more lifelike representation. Planes can be used to depict the curves and contours of an object or subject and can help to create the illusion of form and volume.

1. Begin with a rectangle. The dimensions of the rectangle don't matter.
2. Find the center by adding two diagonal lines from the corners.
3. Using the diagonal lines as a guide, add an X- and Y-axis on the plane.
4. Optionally, you can also add additional vertical and horizontal lines to create a grid.

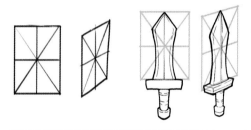

When we rotate the plane in space, we can see how the X- and Y-axes adjust with perspective. We can use these planes as a guide to construct flat subjects.

PRACTICE
We can practice sketching planes in perspective using a sheet of paper. Place the paper on a table and sketch what you see from different perspectives.

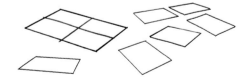

MODIFICATIONS WITH REFERENCE
Next, fold your paper into different shapes and sketch what you see.

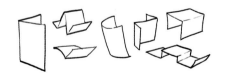

FROM IMAGINATION
Once you feel comfortable, begin sketching planes and modified planes from imagination (see example at left). Try sketching multiple planes that exist in relation to each other in perspective.

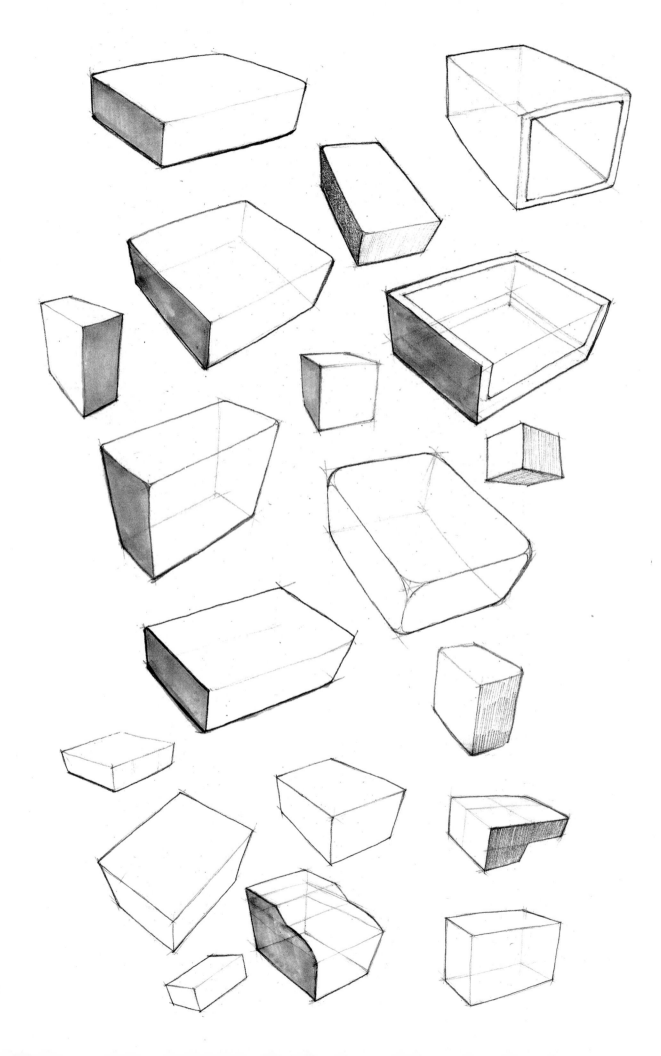

BOXES

A box, or cube, is arguably one of the most useful forms to learn how to sketch. Because we can technically fit any subject into a box, learning how to rotate boxes and cubes in space will allow us to sketch more complex subjects in perspective. Drawing cubes can be very helpful in practicing how to maintain proportions and volume. We can also build hard-surfaced subjects, such as vehicles and architecture, with boxes.

There are several ways to construct boxes in two- or three-point perspective, but I find the following two to be most helpful when freehanding perspective.

 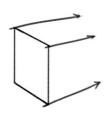 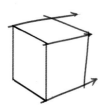 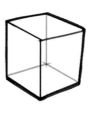

PLANE METHOD

1. Start with a plane in perspective.
2. Draw diagonal lines that align with the perspective (think of the Z-axis).
3. Draw in the rest of the edges. In two-point perspective, all vertical lines should be parallel.
4. Optionally, sketch through the form to check perspective and show the other side.

 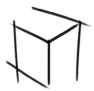 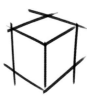

Y METHOD

1. Start with a Y. The two diagonal branches of the Y will be the center lines for each side.
2. Draw the vertical lines for the edges.
3. Starting with one side, sketch in the diagonal lines. Use the center diagonal as a guide. The two lines on the outside should wrap inward toward the center, as these lines will all converge eventually.
4. Finish with the diagonal lines on the other side.

Ellipses

Ellipses can be considered modifications of planes, and they are extremely useful in drawing cylinders and other subjects. In sketching, an ellipse is a circular shape seen at an angle. The flat shape we see in a drawing is an oval, but we are actually depicting a circle seen from different perspectives.

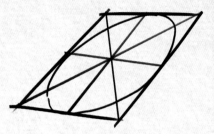

 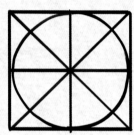

1. Let's start with a square.

2. Cross diagonal lines from opposing corners.

3. Find the X- and Y-axes.

4. Use these parameters to draw a circle inside the square. The edges of the circle should meet the X- and Y-axes on each side.

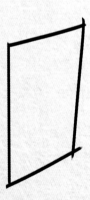 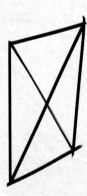 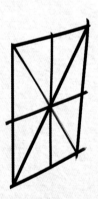 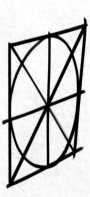

We can achieve the same thing using a plane in perspective.

1. Cross diagonal lines from the corners again.

2. Find the X- and Y-axes. The Y-axis goes straight down, but notice how the X-axis sits diagonally in perspective, following the top and bottom edges of the plane.

3. Sketch an ellipse following the edges of the plane.

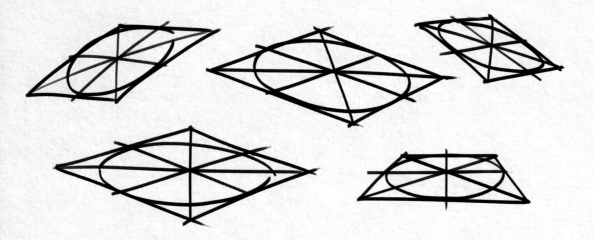

We can practice sketching ellipses using the plane exercise. Fill a page with planes sitting at different angles. Then sketch ellipses to fit in each plane.

As we did with the spheres, we can practice drawing ellipses inside a grid. Try filling a page with ellipses leaning both to the left and to the right.

CYLINDERS

Cylinders and their variations are also commonly used forms. Getting comfortable sketching ellipses will be extremely useful for building cylinders.

A cylinder is made up of two circles and a plane. If you roll up the plane into a tube, it creates the body of the cylinder. We can add the two circles at the end to complete the form. There are several methods to construct a cylinder in perspective.

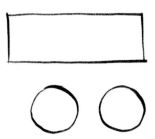
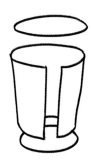

BOX METHOD

We can use a box in one-point perspective as scaffolding for the cylinder. Note that the size, shape, and angle of the cylinder can be adjusted by changing the size and shape of the ellipses (see page 54), as well as the placement of the vanishing points. Notice how the plane on top of the box is slightly flatter than the plane on the bottom. This is because the plane on top is closer to the horizon line. Next we can fit ellipses inside the planes to create the cylinder.

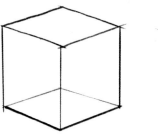
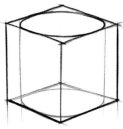

PLANE METHOD

We can also just start with a plane, which will require some freehanding of perspective. Sketch a plane at any angle and find the X-, Y-, and Z-axes for the plane. The Z-axis will be the direction that the cylinder points in. Draw an ellipse inside the plane, and then follow the Z-axis for the walls of the cylinder. Complete the other side with an ellipse slightly wider than the first.

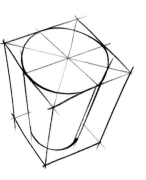

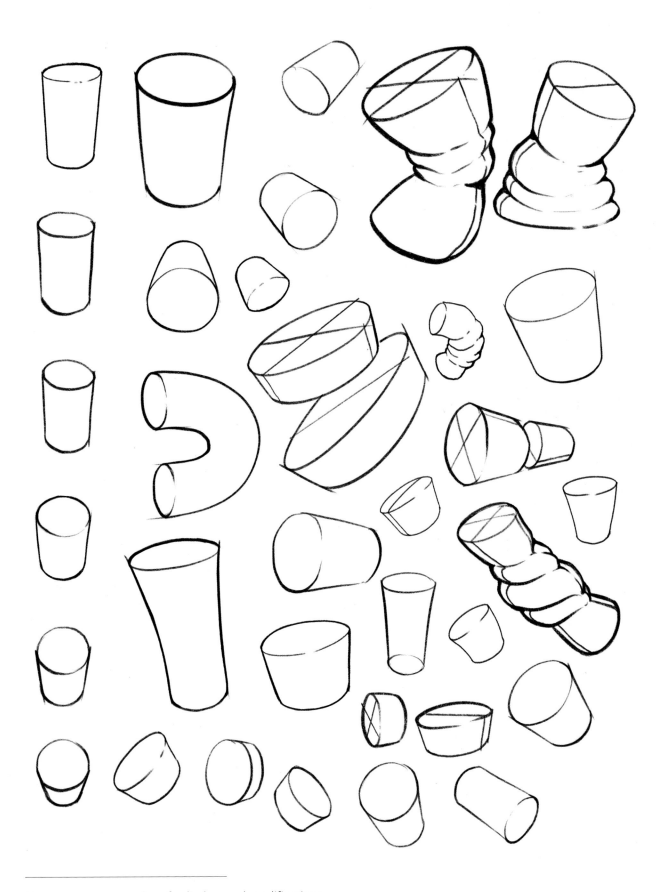

Here are some examples of cylinders and modifications.

SPHERES

We can find spheres in a wide range of subjects both organic and complex, and they can be used as the base structure to build many other subjects. Modifications of the sphere can also be found in all kinds of organic forms and can be used to practice conveying weight and volume.

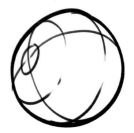

CONSTRUCTION

We can practice freehanding circles first by sketching them inside lines or grids. Be mindful of the speed that you're moving your pen or pencil, as line quality is very important here. After you feel comfortable sketching circles, try drawing ellipses through the form to indicate the dimensions of the sphere.

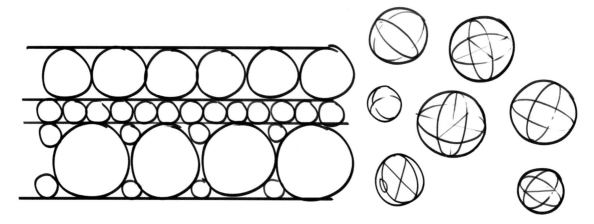

ROTATIONS

Although we don't see sides in a sphere, we can still indicate rotations by drawing through and building out the X-, Y-, and Z-axes. We can also show rotations by drawing the contours of the sphere facing various directions.

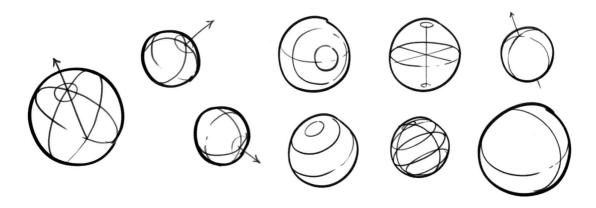

MODIFICATIONS

Organic modifications of the sphere can look like any rounded blob without hard edges. Think about taking a sphere made of clay and stretching it out. Using a piece of clay for reference can actually be a great resource to practice sketching these blobs. Try assigning the contours and center line to these forms.

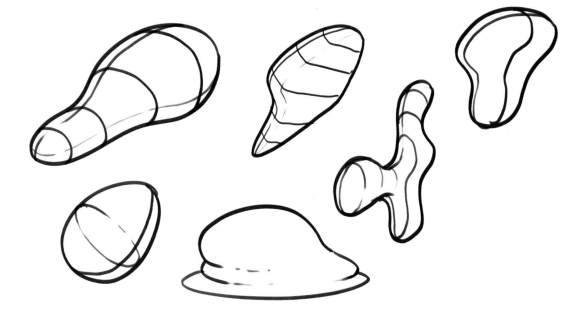

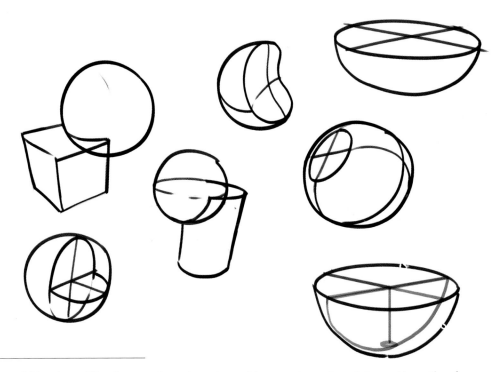

We can also add hard modifications to the sphere by making precise cuts or intersecting other forms. This requires us to really think through the form and understand the volume.

PYRAMIDS

Pyramids are constructed by using a square as the base and four triangles for the walls. We can find pyramid forms in architecture, animals, and complex, hard-surface subjects. Pyramids and cones are used less frequently than boxes or cylinders, but they're still helpful to learn. By freehanding pyramids, we can practice building the X-, Y-, and Z-axes, finding the center, and sketching tilted planes.

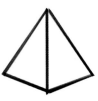

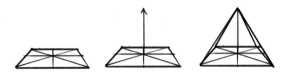

ONE-POINT PERSPECTIVE

1. To sketch a pyramid in one-point perspective, start with a plane on the ground in one-point perspective, and sketch out the X- and Y-axes.

2. Next sketch the Z-axis, a vertical line going straight up from the center of the plane.

3. From each corner of the plane, sketch diagonal lines that converge at the end of the Z-axis.

TWO-POINT PERSPECTIVE

1. To sketch a pyramid in two-point perspective, start with a plane in two-point perspective. Find the center.

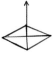

2. Sketch the Z-axis in the center.

3. Sketch diagonal lines meeting at the top of the Z-axis. Technically, we only need to sketch two lines at the outermost edge of the pyramid if we aren't drawing through.

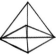
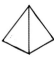

4. Erase the extra lines to create a solid-looking pyramid.

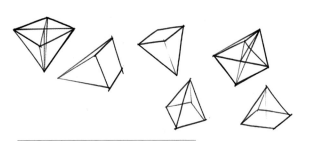

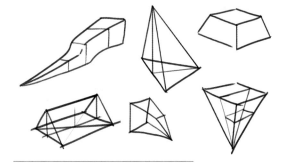

Here are some freehanded rotations of pyramids. Be mindful of that Z-axis and think of how the X-, Y-, and Z-axes relate to each other as this form rotates.

Here are some more freehanded rotations of pyramids. I mainly pay attention to the perspective of the base plane to build off of. Be mindful of that Z-axis and think of how the X-, Y-, and Z-axes relate to each other as the form turns.

CONES

The cone is like a cousin to the pyramid, as it can be constructed in a similar way. It's made up of a circle as the base and a continuous plane wrapping around its body.

1. Begin by sketching a plane that is in one-point perspective.

2. Find the center and sketch in the X- and Y-axes.

3. Sketch an ellipse inside the plane.

4. Add the Z-axis going straight up. In this perspective, notice how the Y-axis and Z-axis align.

5. Sketch diagonal lines from the corners of the ellipse, meeting at the end of the Z-axis. Erase the extra lines.

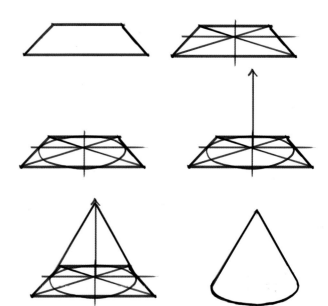

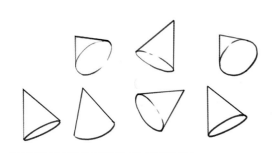

Here are some rotations of the cone. Start with sketching ellipses in different angles.

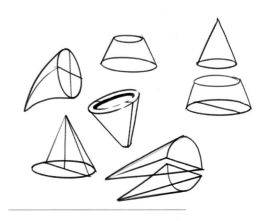

Here are some modifications of a cone.

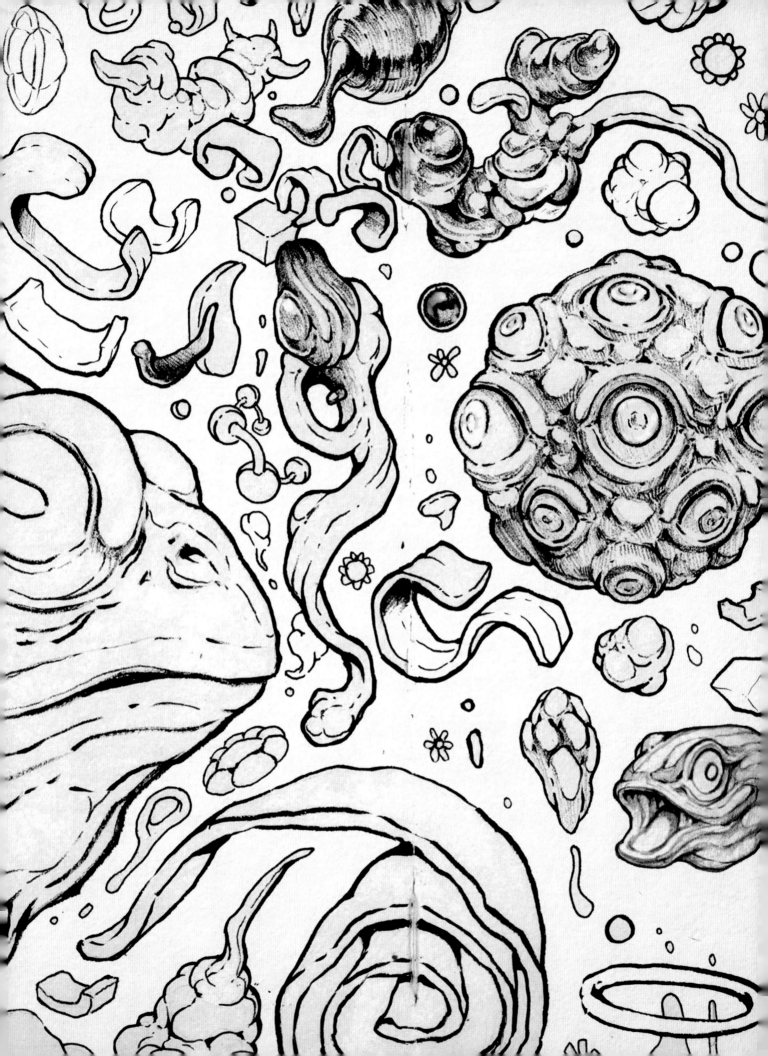

SKETCHING
ON LOCATION

STUDYING A SUBJECT

There are many ways we can approach sketching subjects from direct observation.

SCRIBBLING

This method is perfect for quick sketching and subjects in motion. With this approach, we're trying to capture the movement or essence of the subject. For example, we can start with an action line that runs through the subject.

Then we can build forms around it. We can loosely build the scribbles to describe the form, or just the overall silhouette. It can also be helpful to use a translucent medium to leave room for values later on.

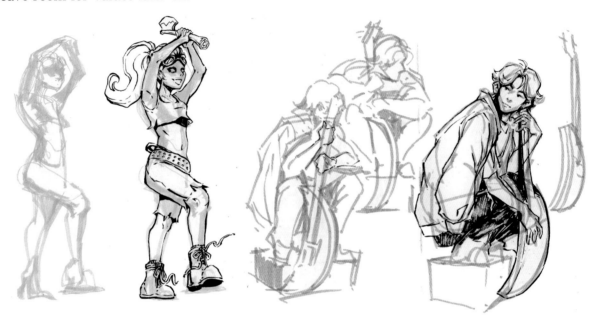

SILHOUETTES AND SHAPES

Another approach is to just look for the two-dimensional shape of the subject. I can create tiny thumbnail silhouettes of my subject, or I can add some detail. I also love blocking in a silhouette and then revisiting it with line work.

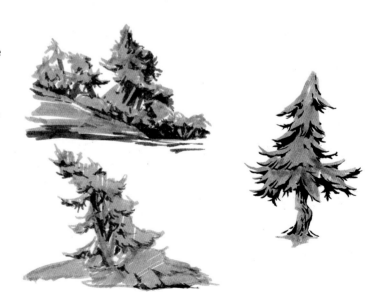

BASIC FORMS

We can break down the subject into the basic forms we looked at before. Every subject, regardless of how complex, can be simplified in a similar way, and there isn't a singular way to break down a subject.

We can use these simplified forms as the foundation to carve in detail and add values. Getting comfortable sketching the basic forms in perspective is extremely useful and will assist you in sketching everything else you see.

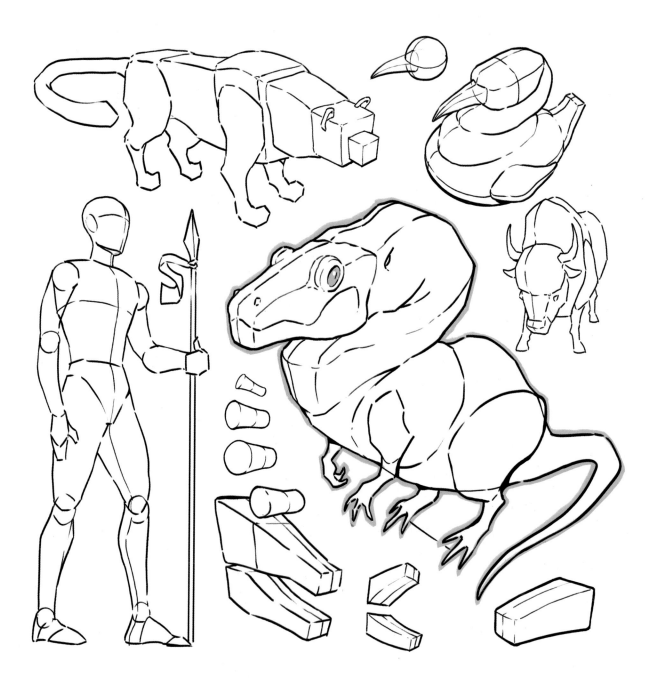

DISTANCE

Distance is a key component when it comes to sketching, and how we depict subjects. You wouldn't treat a tree that is the main character of your illustration the same way you would a row of trees sitting in the background. Sketching the same subject at varying distances will help you to think about different ways you could approach the subject. Let's use a tree as an example.

CLOSE UP

I'm starting at the closest distance. At this point, what I can observe is limited. I could do texture studies of the bark or take note of the color changes I see up close. I might look up and sketch out individual leaves and branches. Right now I'm not drawing the entire subject itself, but observing its components.

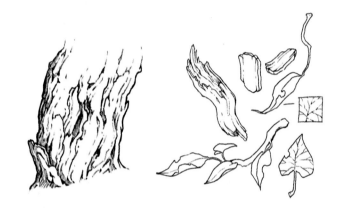

MIDDLE DISTANCE

Next, I'm going to take a step back so that I can see the entirety of the tree. I'm still close enough to make out some detail, but some of it starts to fade. At this distance, I can sketch out the entire tree, and I have to balance light, shadow, and detail. If I were to detail the subject at this point as I did in my first texture study, the sketch might be way too busy. I'm also refraining from drawing individual leaves, and I'm starting to group them into bigger shapes.

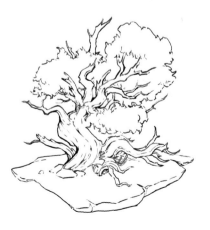

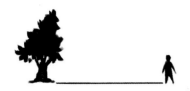

LONG DISTANCE

Finally, I'm stepping way far back until the subject is very small. I may not be able to make out much detail at all. At this point, we can just simplify light and shadow and focus on the overall shape or silhouette. I can still use interesting shadow shapes and mark-making that will inform the texture of the subject.

This idea can apply to any subject. Think of things that you tend to see in your daily life and how they might start to change as subjects or sources of inspiration depending on the scale, or distance.

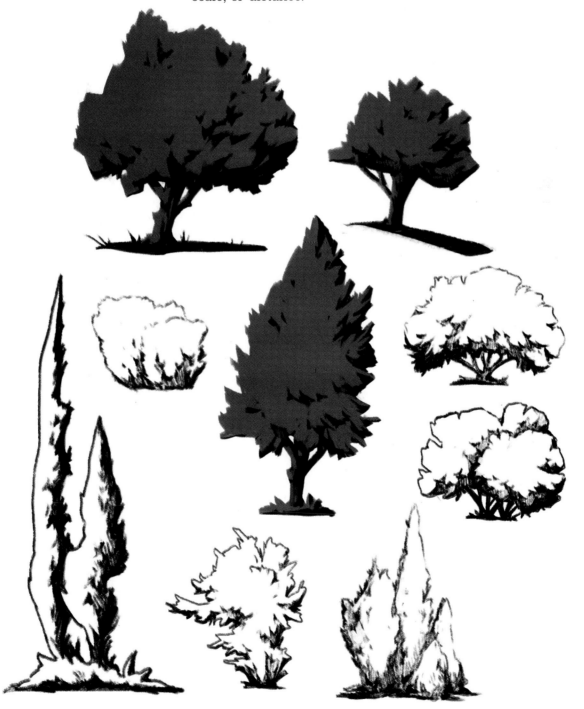

DETAIL

Adding details can be a tedious but rewarding part of drawing. The amount of detail in a sketch can determine the visual impact of the piece. Thinking about components such as texture, lighting, and values can help to create a more realistic representation of a subject.

At the same time, adding too much detail can sometimes detract from the overall impact of a sketch, by scattering the focal point and overwhelming the composition. Finding balance between detail and rest in your sketch or composition is key.

ESTABLISH AN OBJECTIVE

The amount of detail to include in an image depends on the objective of the sketch. Is it a quick sketch that doesn't call for much detail? Are you rendering the main subject of your illustration? Think about how you can utilize the amount of detail to convey your intent.

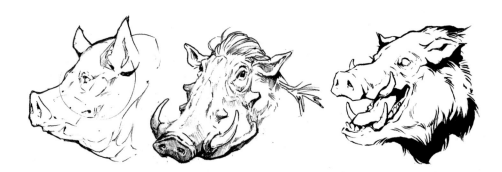

FORM IS KING

Adding too much detail can sometimes oversaturate or unintentionally flatten out a drawing. The tree on the left has more information than the three following, but it's leaning towards having too much information. Focus on establishing form first, and be mindful when finding a balance of light and shadow.

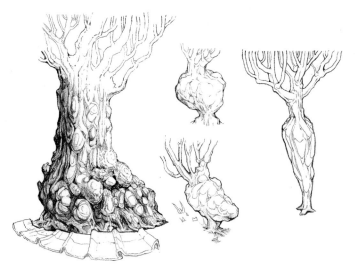

CLARITY

Does the amount of detail inform or detract from your objective? Does your image communicate what you are trying to say? Here is an example where I find the amount of detail to be distracting. To establish more clarity, I could reorganize the amount of contrast to bring back focus to the subject.

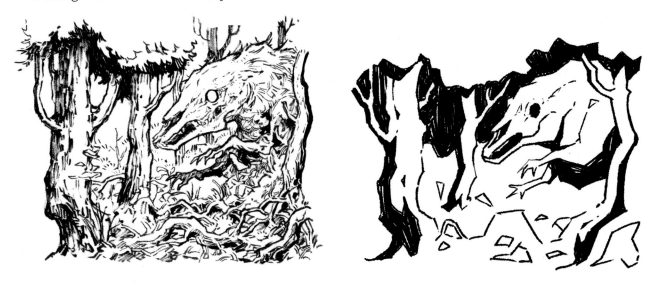

BREAK THE RULES

Maybe you want to intentionally overwhelm your sketch with as much detail as possible. Here is an example where I overloaded the sketch with detail and gave every part of this plant equal attention. There's no correct approach; it all goes back to your objective.

DURATION

Time is another factor to consider when working in your sketchbook. Every sketch doesn't require hours of careful rendering. Depending on the amount of time you have, you can sketch from life with different approaches.

QUICK SKETCHES

Quick sketches are such a great way to learn and study subjects when you don't have much time. They're used to capture the gesture or movement of a subject, rather than trying to render it in great detail. This can be especially useful when working from life, as it allows you to capture fleeting poses and movements. When working quickly, the marks on your paper are just artifacts of what your eye is following. Take the pressure off yourself to make these sketches perfect or accurate. I have a senior dog that walks very slowly, so I love doing some quick sketches while he wanders around outside.

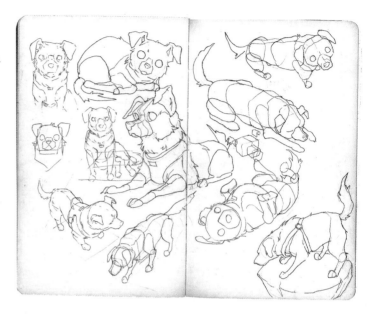

10-MINUTE SKETCHES

If you have more time, ten- to twenty-minute sketches provide an opportunity to add detail and explore the subject further, while still working quickly. Working with a permanent medium can also force you to move forward without constantly erasing.

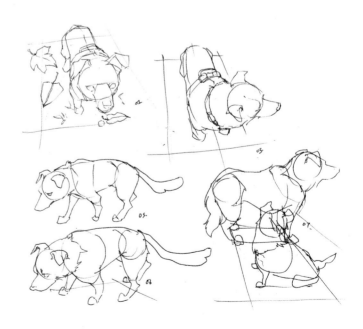

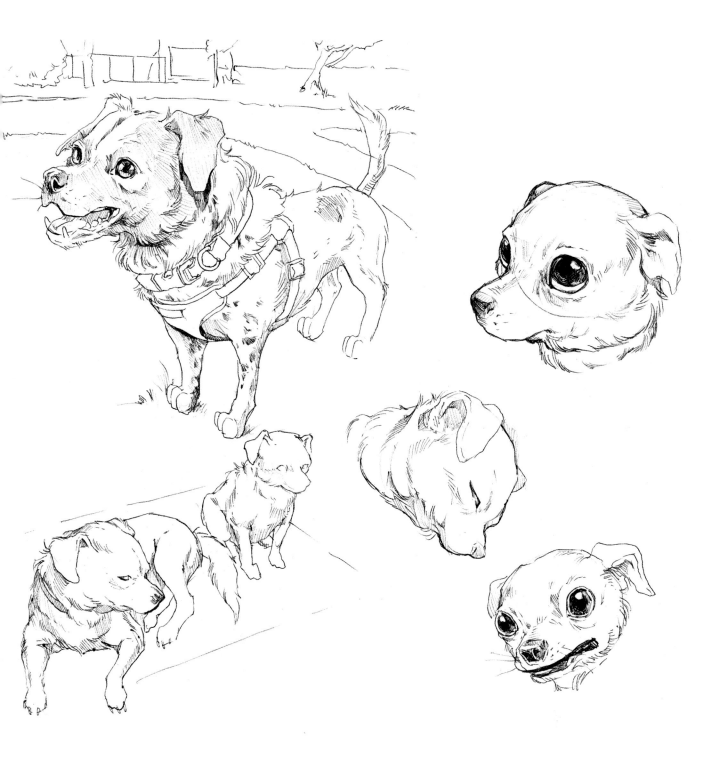

LONGER SKETCHES

Longer sketches, which can take an hour or more, allow for a more comprehensive and detailed exploration of the subject or scene. We can plan and think about value, color, and texture. These longer sketches allow us to create more finished and polished pieces, or to take the time to experiment with different techniques and styles.

THUMBNAILS

Composition refers to the placement of objects in an artwork. A thumbnail sketch allows you to arrange objects and values in different ways to achieve a pleasing composition. Composition is something I'm still working to improve on, and thumbnails are a great way to practice it. Using small thumbnails can also make the sketching process much more approachable. It also allows you to go through many compositions quickly without burning too much time on one image. I find that the more iterations I do, the faster I become comfortable approaching the subject or drawing from imagination.

These thumbnails are a lot more detailed than they need to be, but I had a lot of fun drawing them. These were done in the middle of the woods in Idyllwild, California. When I'm looking for or trying to build a composition, I like to think about the scene in abstract shapes. How can we organize abstract shapes to make interesting arrangements or create a narrative? A great exercise is to make some thumbnails and fill them with abstract compositions using two values.

There are many different approaches and no rules to creating thumbnails to practice composition, but here are three processes that may be helpful.

 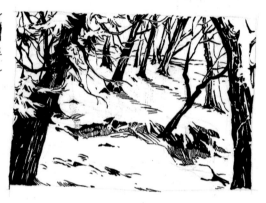

TWO-VALUE STUDIES

Using only black and white, create a very simplified thumbnail of your scene. Focus on using shapes rather than lines.

THREE-VALUE STUDIES

The white of the paper is your lightest value. Using a toned marker, block out basic shapes for your composition. Take a black pen and add one more value to indicate areas of shadow.

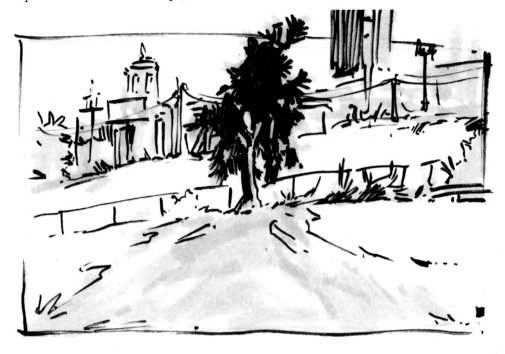

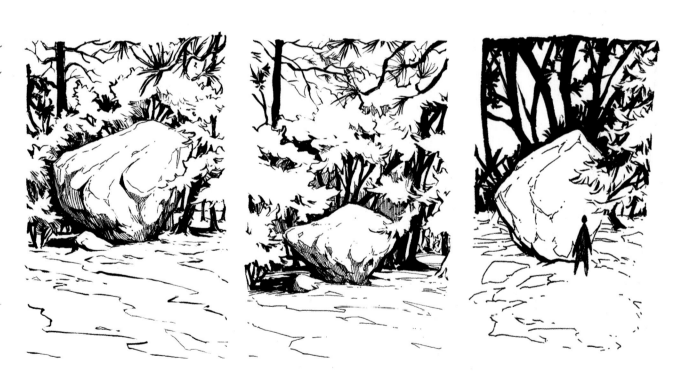

These three thumbnails are variations of the same scene. In the first thumbnail, I felt the rock was too big and too centered, so I tried lowering the ground plane and using the rule of thirds in the second. The rule of thirds means dividing up the composition into thirds and placing the focal point in one of those sections. This creates visual balance in an image. In the last thumbnail, I tried introducing a figure and creating more contrast between the rock and the background to frame the subject.

TYPES OF SUBJECTS

Everything that we see can be broken down and simplified in similar ways, but different subjects allow us to focus on specific techniques. Drawing different types of subjects can also help to broaden your visual library that will provide inspiration for future artwork or designs. By practicing drawing a variety of subjects, you can develop a well-rounded set of skills and techniques that can be applied to any subject matter.

We can simplify all subjects into two groups: organic and structured.

Organic subjects include plants, food, animals, and humans. They are softer and more fluid. Organic subjects call for more form sensitivity, movement, and weight.

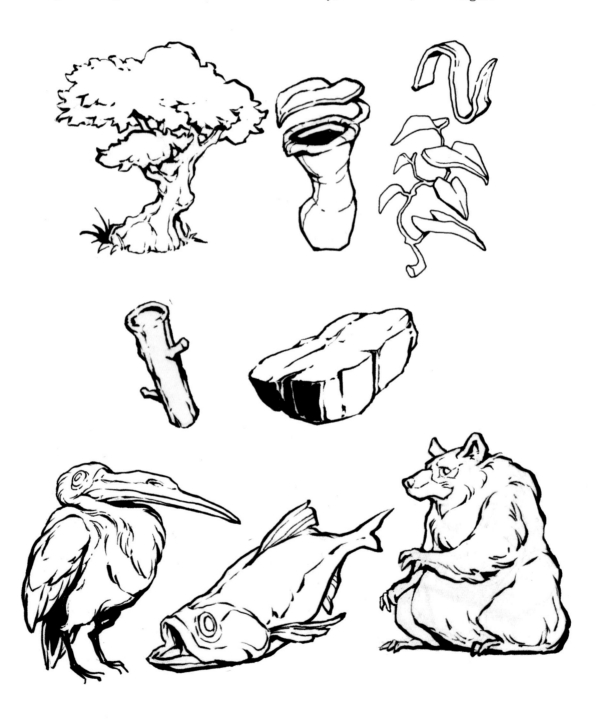

Structured subjects include hard-surfaced props, machines, vehicles, and architecture. They tend to need more precision, symmetry, and perspective.

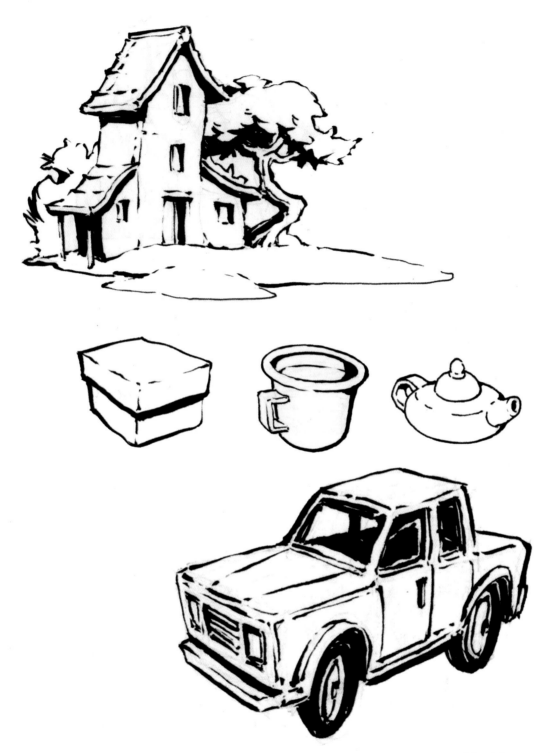

This doesn't mean that these subjects have fixed properties. We could add tons of structure to organic subjects and organic interpretations to structured subjects.

In the next chapter of this book, I'll go through how I approach each type of subject matter, with examples.

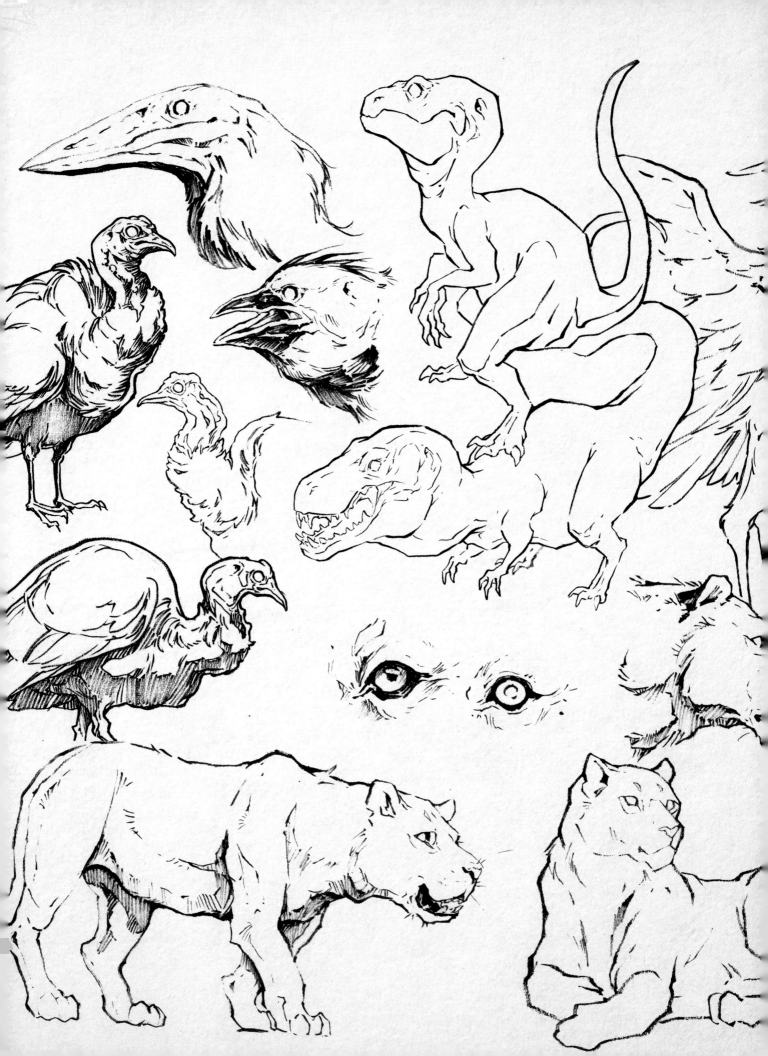

ANATOMY
OF A
SKETCHBOOK

SIMPLE PROPS

In this chapter, we'll be going through my sketchbooks to take a look at different types of subject matter and approaches to sketching. The examples shown here go from simple to complex and are a mix of sketches on location, from personal photo reference, and from memory or imagination.

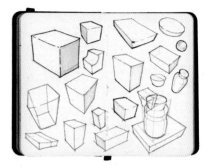

Let's start with subject matter you can use as a reference without even leaving the house. To practice sketching from direct observation, we can look for specific subjects to start with. If you're new to sketching, or just want to practice fundamentals, look for subjects that resemble the six basic forms, especially boxes and cylinders. Think of simple objects around the house such as cups, furniture, and appliances. Focus on form and simplify the subject into basic shapes.

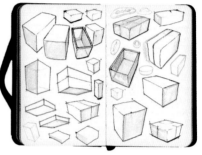

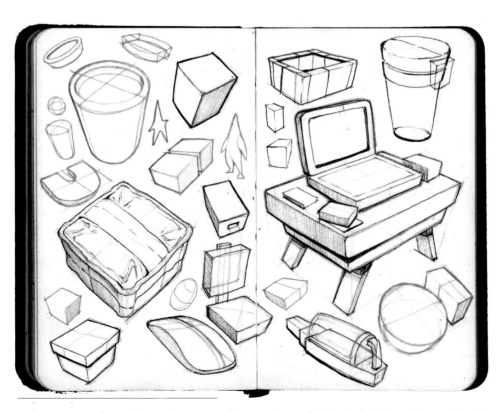

This page was done in ballpoint pen and colored pencil. I simplified the subjects directly around me and tried sketching them from a different perspective.

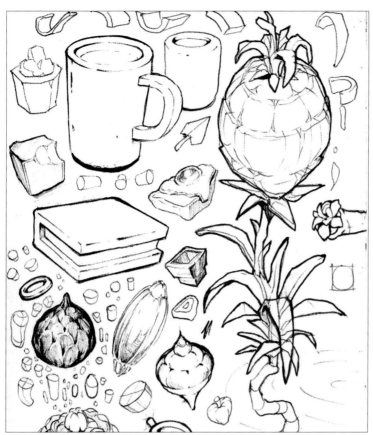

This page is a mix of doodles from direct observation and imagination. Again I'm focusing on basic shapes and keeping the sketches under five minutes each.

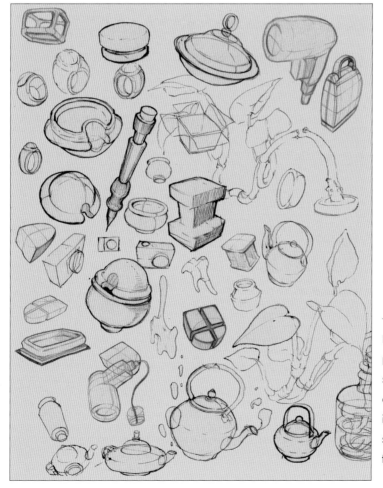

Here are some more sketches of simple props. I usually try to draw the same subject from multiple perspectives, or once from observation and then from imagination. I try not to linger on one sketch for too long. If the perspective or form is off, I just let it go and move on.

ABSTRACT ORGANICS

Abstract organics are subjects that don't have fixed or defined forms or proportions, such as food, rock formations, coral, driftwood, and bones. These subjects can be great for exploring volume, texture, and form sensitivity without having to concentrate too much on proportions.

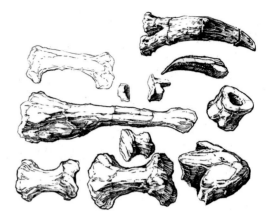

I love looking for interesting rocks, shells, and pieces of wood for reference when I'm out in nature. When we look closely at these smaller subjects, we can find an infinite amount of detail. These subjects are great for exploring how much detail we want to include in our sketches.

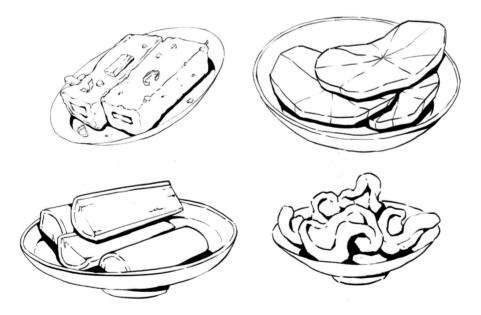

Food is one of the most accessible references we have and provides an infinite combination of interesting shapes. We can use the container holding the food to block in perspective. These are photo studies and sketches from imagination created in Procreate.

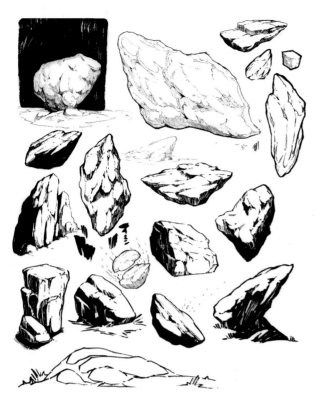

Rock formations are a mix of structured and organic forms. When sketching rocks, I prioritize establishing the dimensions before showing texture. These studies were done in ballpoint pen and ink.

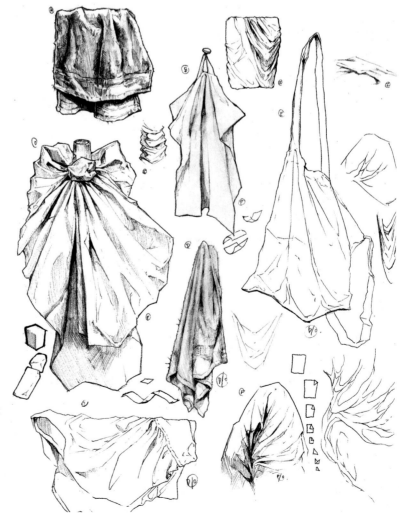

Drapery and fabrics are also great abstract subjects to study. These fabric studies were done in ballpoint pen and graphite and are a mix of direct observation, photo reference, and imagination.

SKELETAL FORMS

When it comes to sketching skulls and skeletons, we do need to start thinking about proportion and structure. Natural history museums are wonderful places to sketch skeletons, as well as taxidermy animals and their environments.

We can use simplified skeletal forms as a wire frame to build animals and creatures. This is helpful for figuring out the pose and proportions before starting to add details.

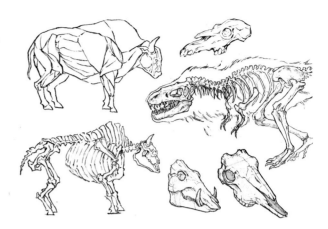

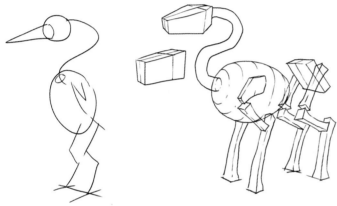

We can treat them as the main subject.

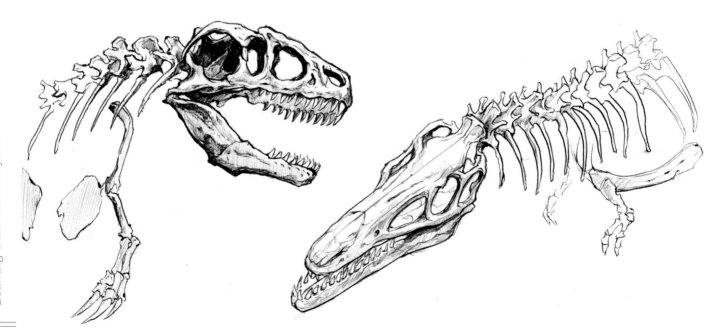

Drawing Basics and Beyond

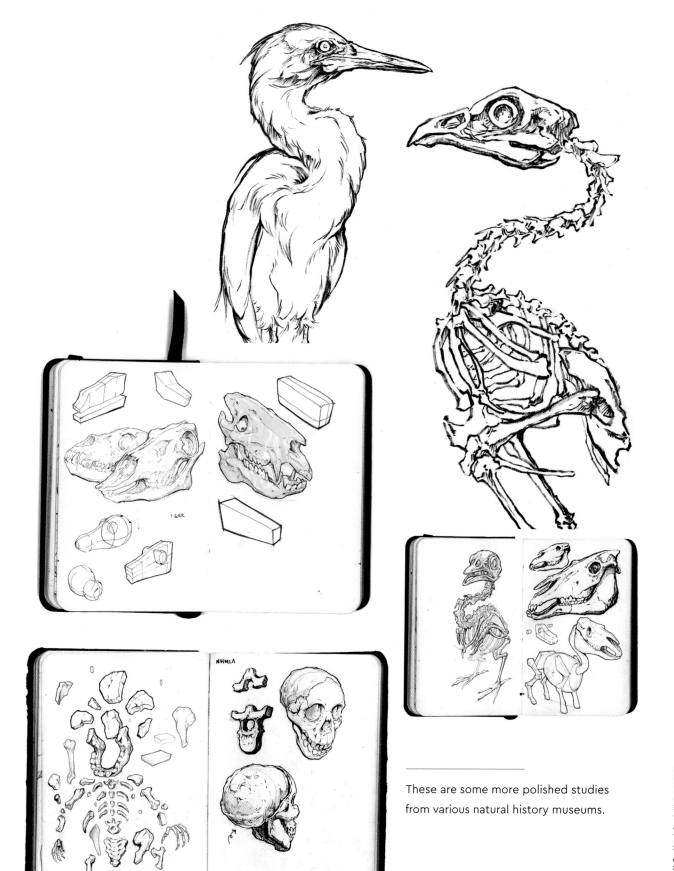

These are some more polished studies from various natural history museums.

PLANTS AND TREES

Now let's add some more form and proportion. Plants have the following defined components:

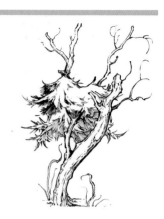

Roots + trunk + branches + leaves = tree

They don't have fixed proportions. This makes them extremely approachable subjects that can be as simplified or as detailed as you want. It feels almost meditative when I get to sketch plants from life. There is so much nuance and detail to get lost in.

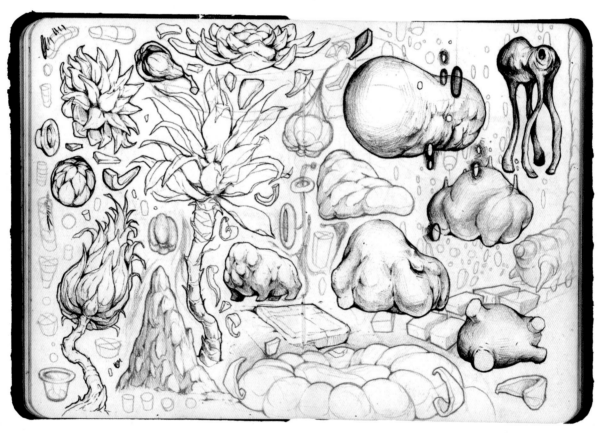

I like to divide plants into three categories: forms, groups, and sheets.

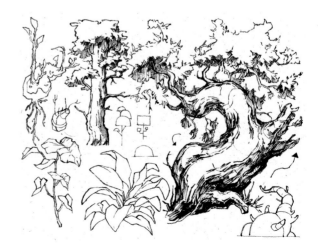

FORMS

Form-heavy plants are subjects such as cacti, fungi, fruit, and any plant that has a clear mass or volume. When sketching these plants, I focus heavily on defining perspective and volume.

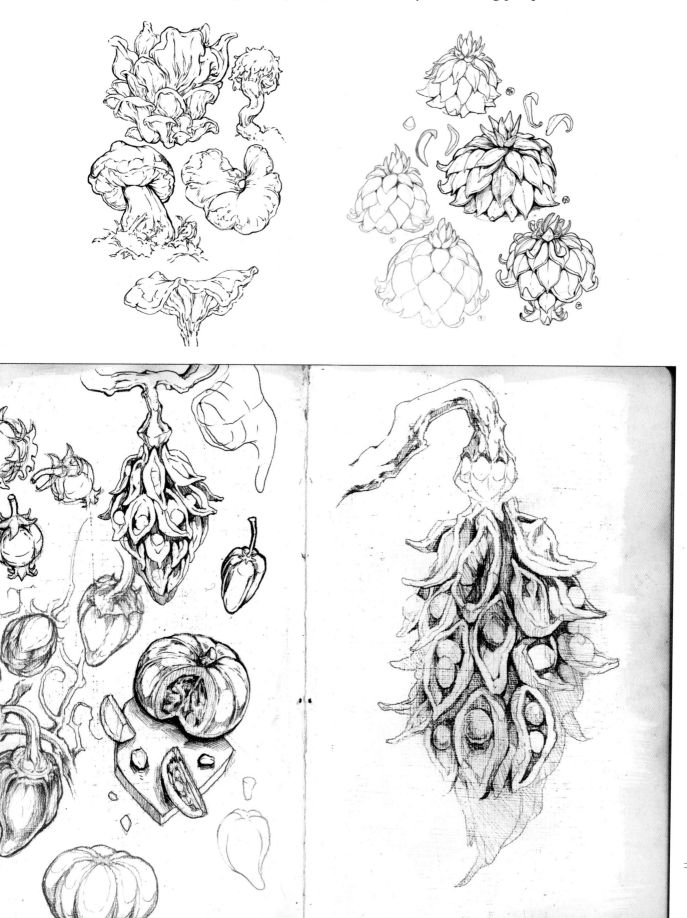

GROUPS

We often see plants that exist in groups, such as trees and leafy plants. This also applies to plants or groups of plants at a distance. When we look at a bunch of small elements together, it can be more economical to group them together into a mass and indicate detail through texture, rather than drawing out every single leaf.

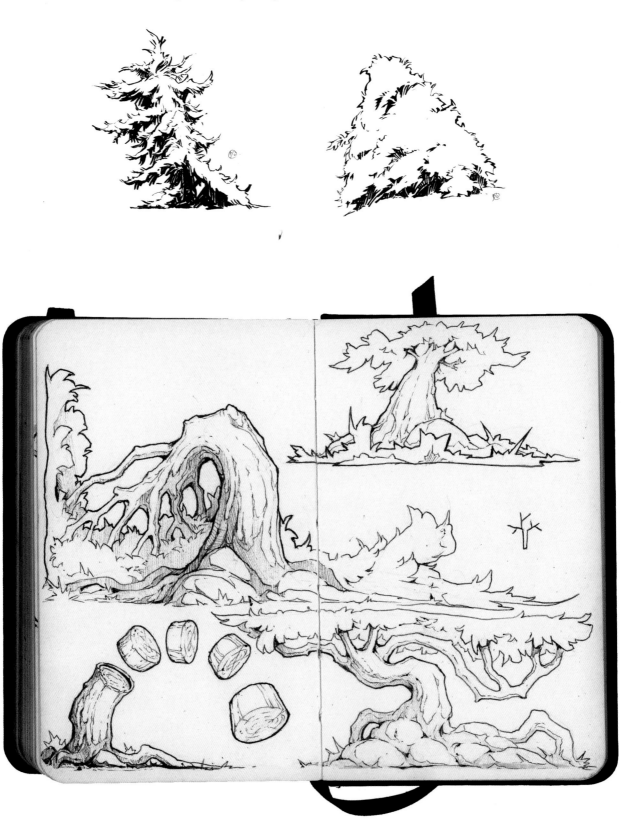

SHEETS

Examples of sheets in plants include petals and leaves, especially up close. When you look at plants that resemble sheets, think about folding or turning a piece of paper. Pay closer attention to the subtle turns and plane changes in the subject. You can also exaggerate detail and form sensitivity.

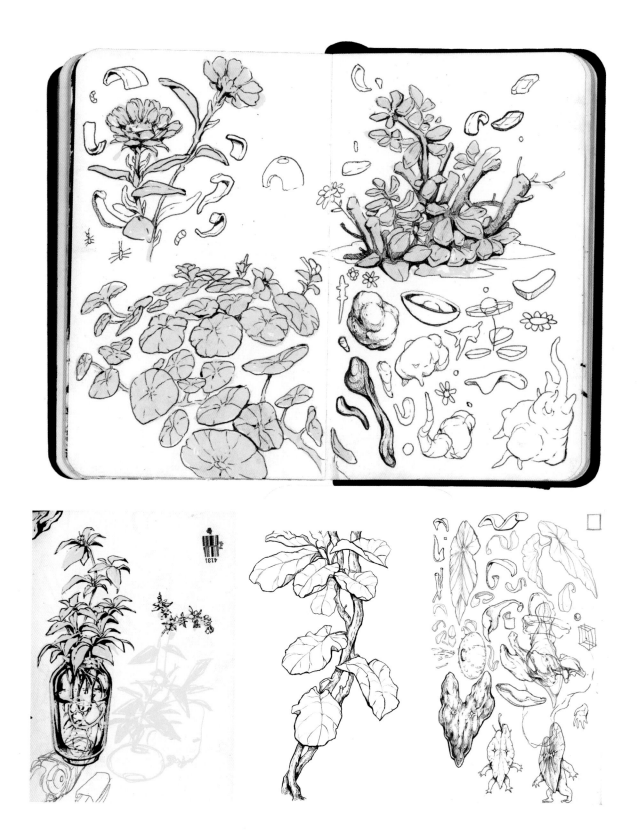

ANIMALS

Animals are my favorite subjects to draw. Next to humans, animals are the most complex organic subject matter. They have fixed proportions, moving parts, textures, and complex features. It can be extremely helpful to observe and sketch animals in real life, but because they're constantly in motion, you can also supplement with reference photos, videos, and taxidermy specimens. Some places to find references to draw are natural history museums, zoos, parks, and nature preserves.

It's easier to start with the side views if you're studying proportions, so you can see everything. Most animals have bilateral symmetry, so you can get all the information you need from one side.

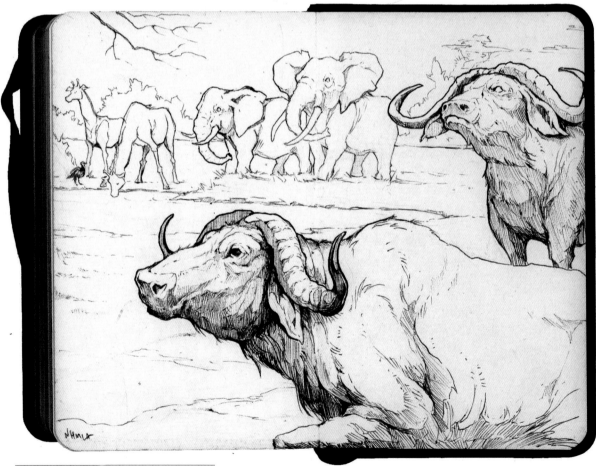

Study of a display from the Natural history museum in Los Angeles.

DRAWING ANIMALS FROM LIFE

When drawing from life, I usually focus on familiarizing myself with movement, simplifying basic forms, or capturing interesting perspectives of the animal–what I can't get from a still photo. I can always add details and polish up the sketches at home with additional photo reference.

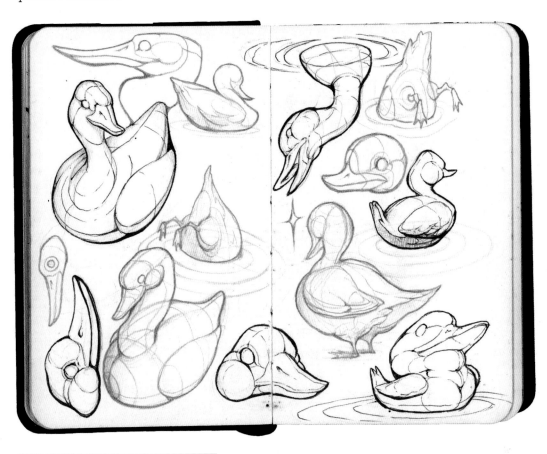

I sketched these ducks in different positions.

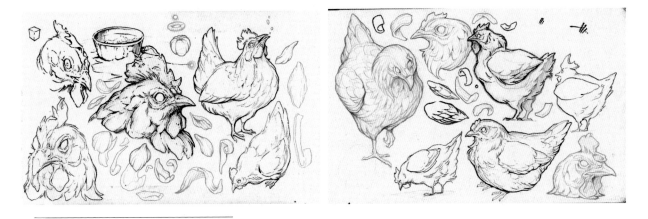

There is a family of chickens that lives in the arts district that I've been visiting regularly. I mostly do gesture drawings on location, then I'll try to draw them from memory at home.

ZOOS AND SANCTUARIES

Here are some sketches from various zoos and animal sanctuaries where I got to sketch some animals from life. I began with some small thumbnails focusing on the basic forms, then worked up to more detailed sketches with colored pencil and ballpoint pen.

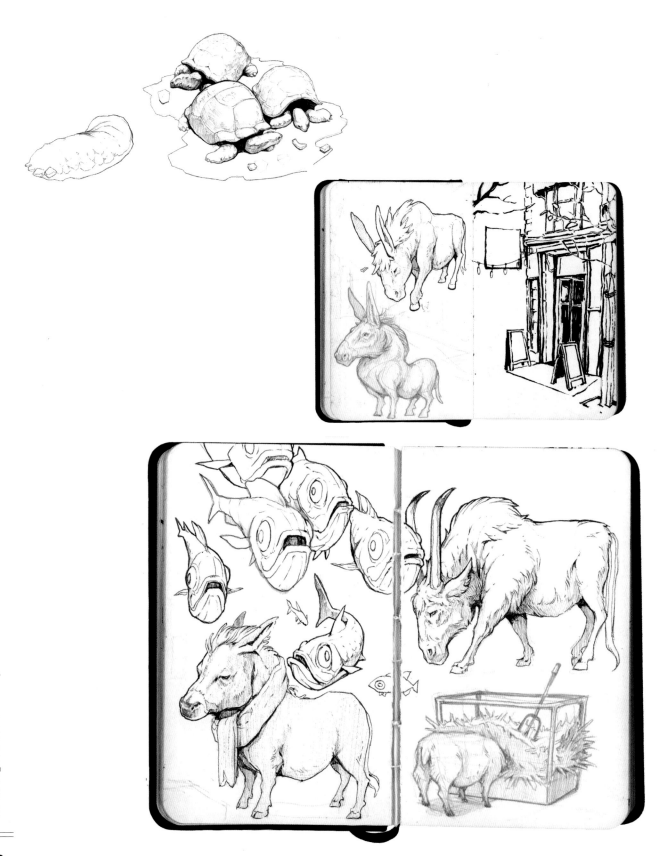

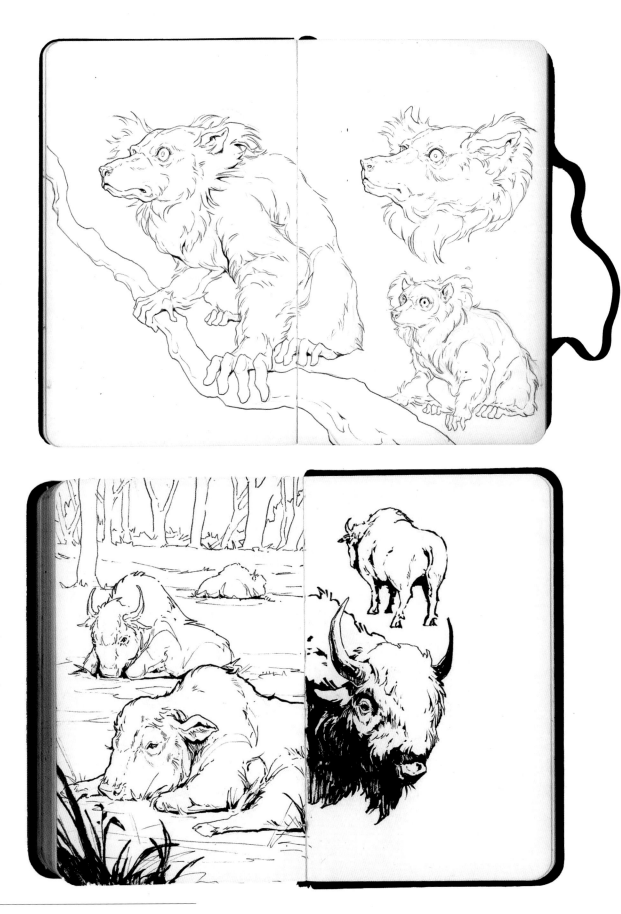

These sketches were from a drive through a bison reserve in Missouri. I had a lot of difficulty getting the likeness and sense of weight while sketching these animals. This spread was done in pencil and brush pen.

DRAWING PETS

Pets are great subjects, especially because you get to observe them so closely at all times of the day. Because we're intimately familiar with their features and proportions, we notice any inconsistencies with proportion or likeness. This means that sketching people or animals we know well is more challenging than an animal we've never seen in real life, but this is also what makes them great subjects.

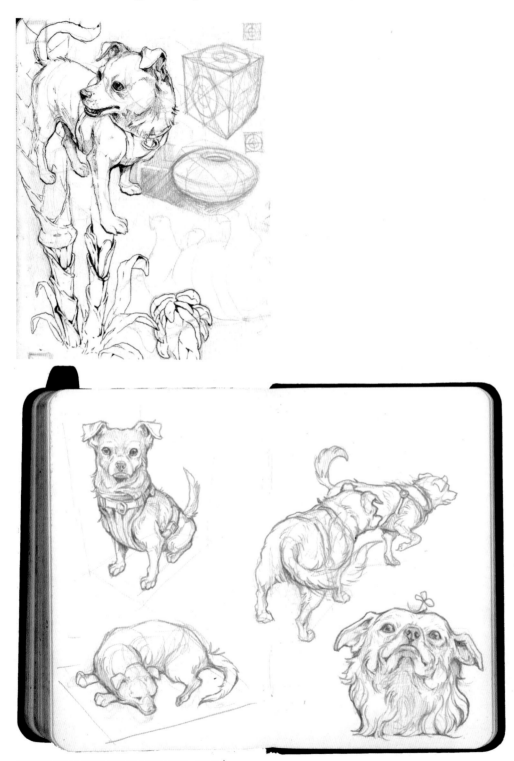

These pages are from observation and photo references of my dog.

SPECIMENS

A few years ago I started collecting insects. I find them so fascinating, and they make wonderful subjects to study. Insects sit somewhere in between organic and structured subjects, so they're extremely useful (and challenging) to draw.

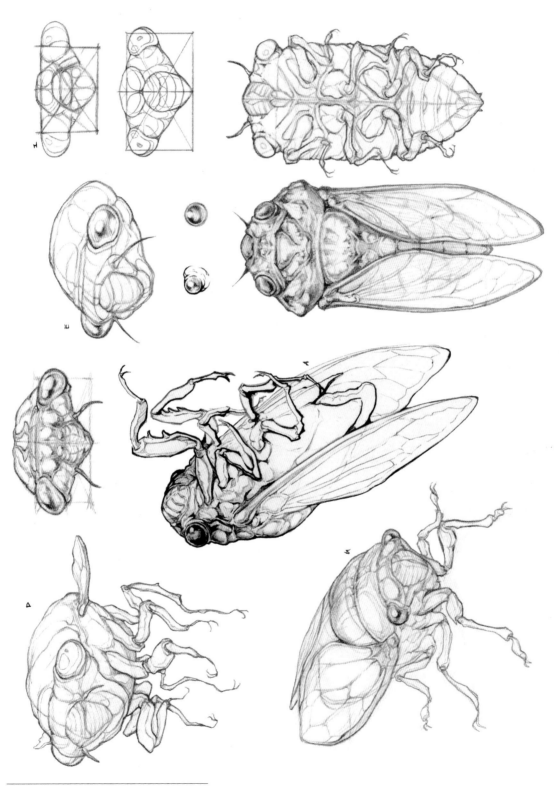

This cicada was the first insect in my collection.

NATURAL HISTORY MUSEUMS

When you sketch at a natural history museum, you get to closely observe subjects that would otherwise be in motion. Displays that include multiple animals are great for practicing perspective and composition because the subjects are already arranged and posed. There is also sometimes an added bonus of an environment in the backdrop, and animals are usually portrayed in a representation of their natural habitat.

 I highly recommend visiting a natural history museum if you have the opportunity and taking advantage of the opportunity to sketch the same subject from multiple angles.

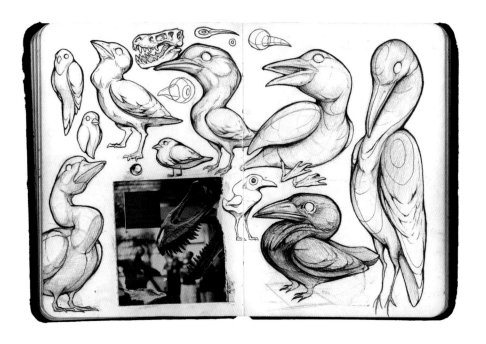

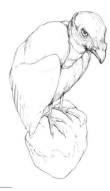
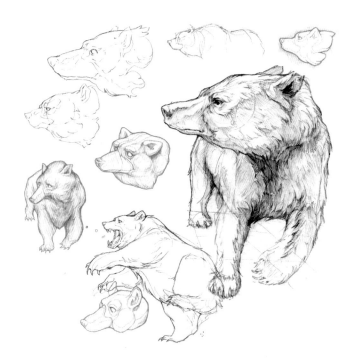

Although these examples are mostly rendered, don't feel like you have to spend a really long time on a single subject. Giving yourself a time limit of ten to twenty minutes per subject, and then just moving onto the next can be a fun exercise and prevent you from getting bogged down in the details.

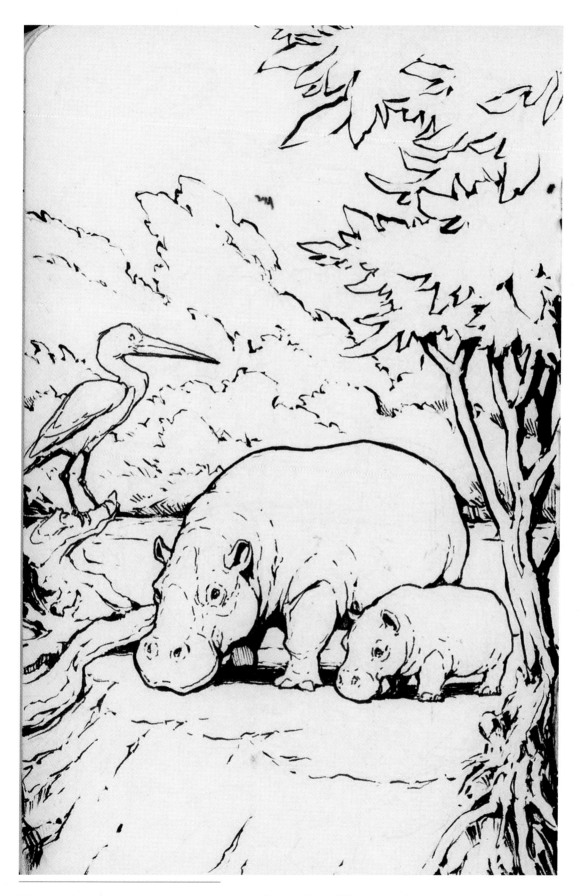

Museums have been a great resource to practice placing subjects in environments.

Here are some sketches from the Natural History Museum in Los Angeles. These pages were done in colored pencil, ballpoint, and ink.

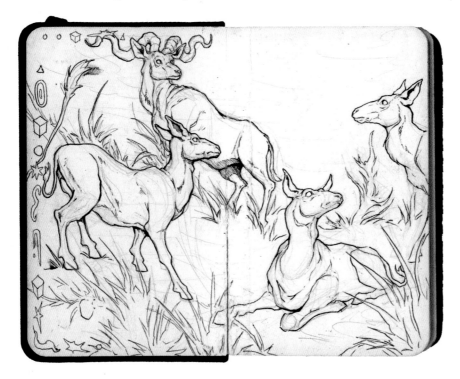

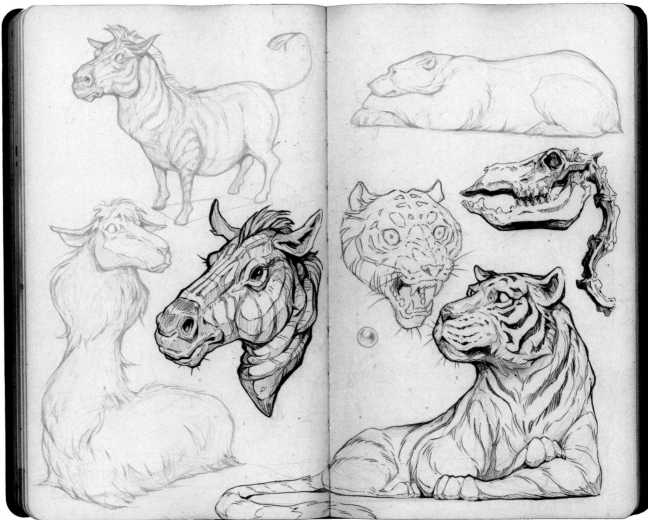

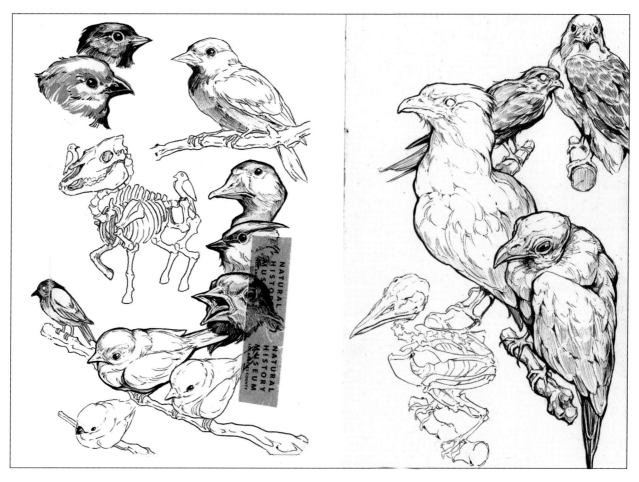

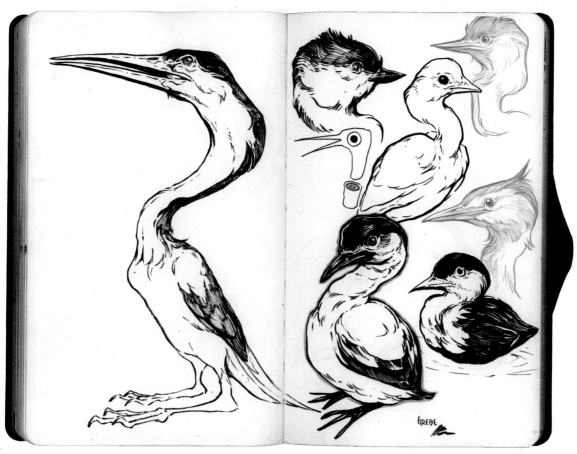

GREBE

PEOPLE

Human beings are some of the most complex organic subjects to draw.

Just like any other subject, humans are made up of shapes, and we can always simplify. For example, the head could be simplified as shown below.

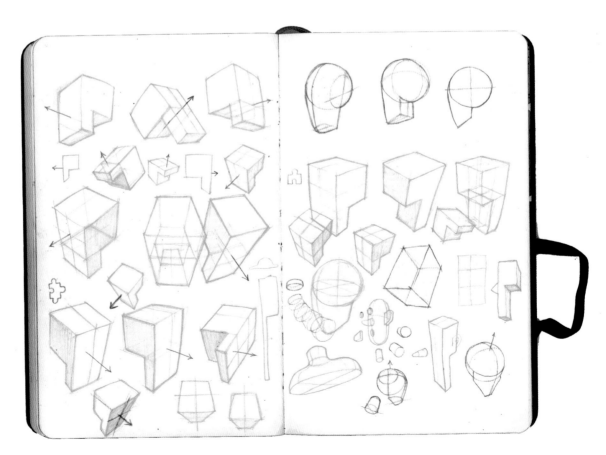

The body can be simplified, as shown below. Notice how most of these forms can be simplified into boxes or cylinders. Being able to sketch these basic forms and rotate them in perspective will help in sketching more complex subject matter.

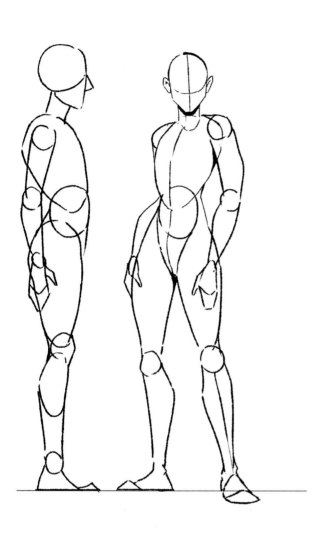 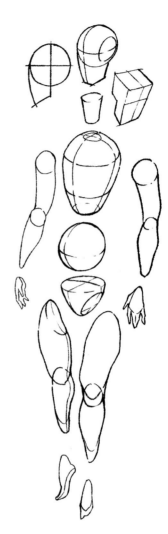

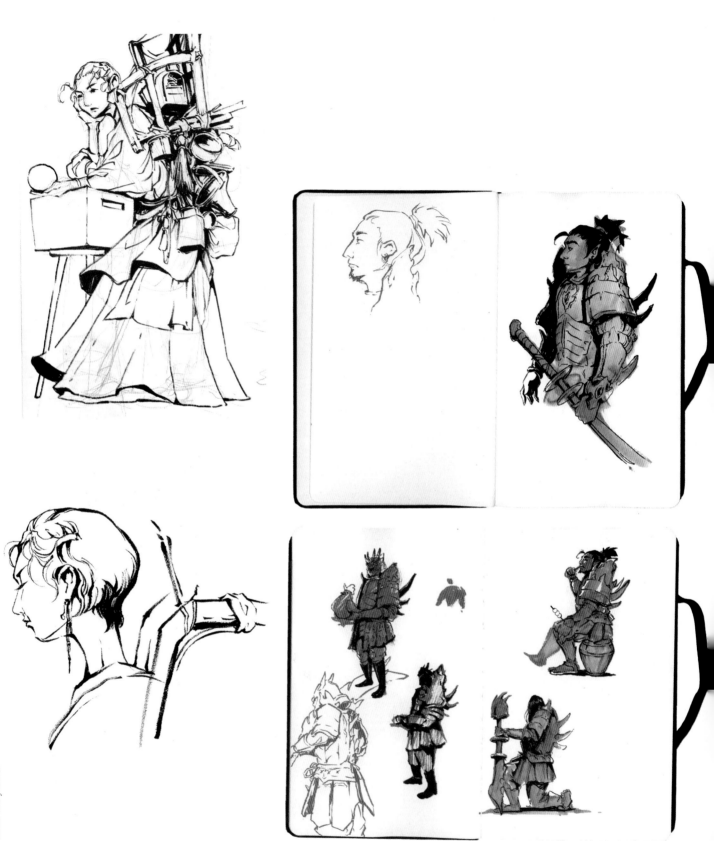

Here are some sketches from figure drawing sessions at the Drawing Club LA. These range from 2- to 10-minute poses. The models often wear costumes, making for really fun sketches and a great opportunity to practice drawing clothing. I started with a rough scribble with a marker and or colored pencil and inked over it with a brush pen or digitally.

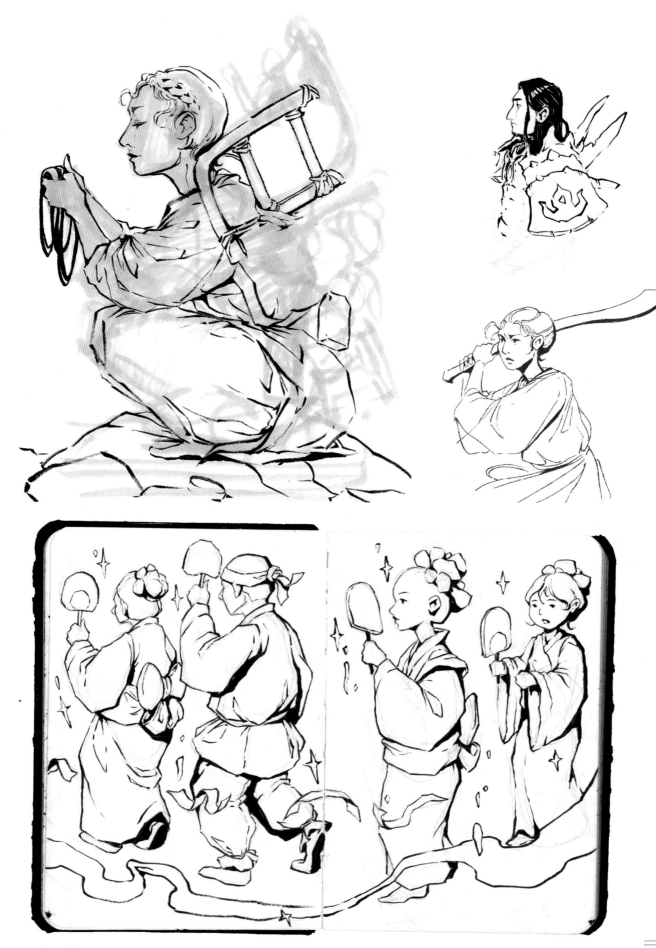

COMPLEX PROPS

Moving back toward more structured subjects, let's take a look at some complex props. Earlier we focused specifically on boxes and cylinders, but now we'll be adding more challenging forms and modifications.

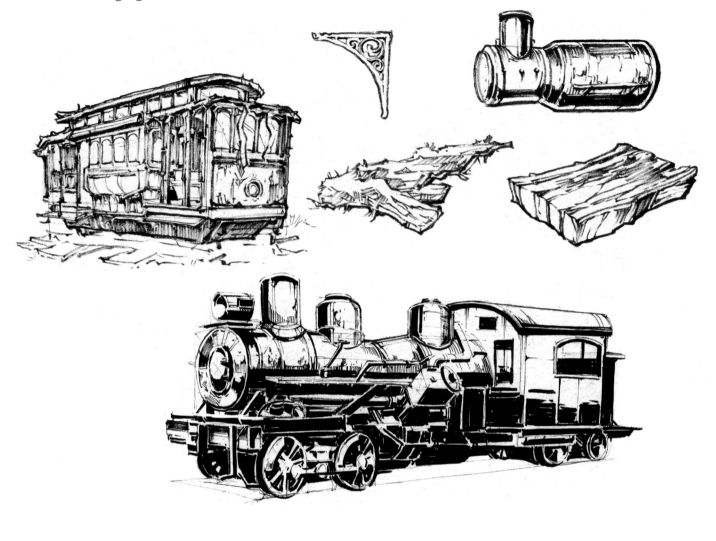

SIMPLIFYING COMPLEX OBJECTS

This type of subject asks for a bit more construction and precision. Even as these forms get more complex, remember we can always simplify down to those basic forms.

It can be easier to look for small modifications of basic forms to start out, or to look for more intricate subjects that still have a simple base shape.

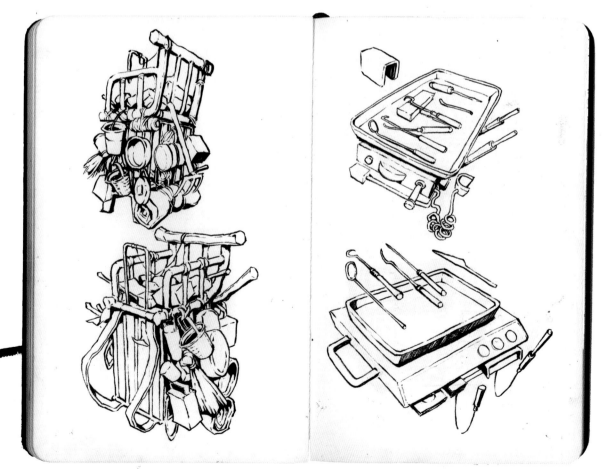

VEHICLES

Sketching vehicles can feel intimidating, but they can be broken down like this: the "head," "body," and "tail." We begin with a side view to get a read of the proportions, and we can project this into a three-quarter view.

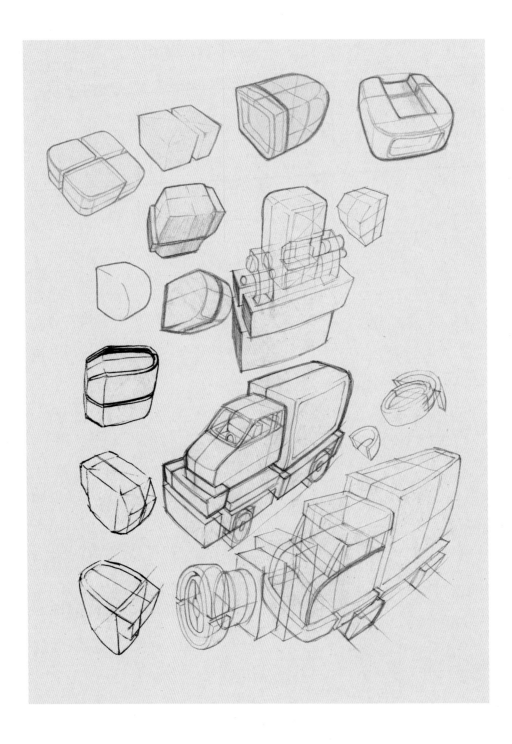

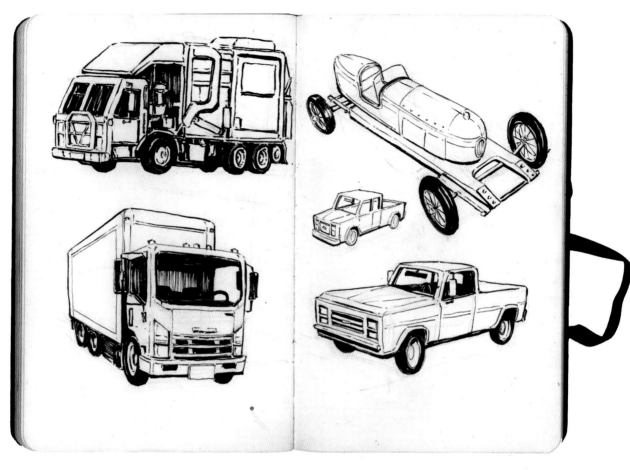

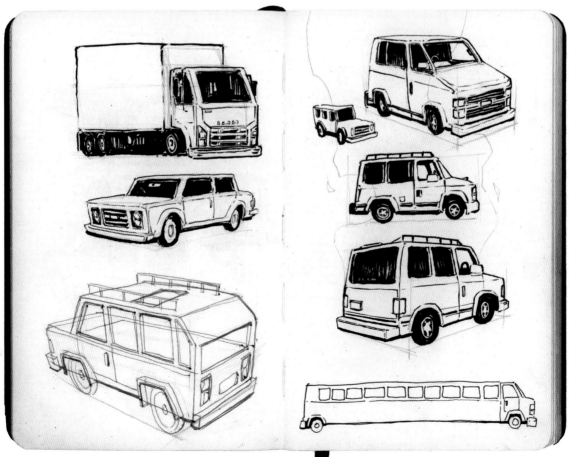

SCENES AND ENVIRONMENTS

Sketching scenes and environments gives us the opportunity to put everything together, like shooting a movie or setting a stage. We can also separate environments into organic and structured scenes. A scene in the middle of a forest, for example, is made up of more organic and erratic shapes, while a cityscape is more structured. Start with whichever type seems more accessible, approachable, or appealing to you.

ADDING CONTEXT

If taking on a complete environment feels intimidating, start by just adding a bit of context to the main subject you're sketching.

Here again I'm playing with the same scene using different distances and distant angles. Doing this tells a whole story about a place.

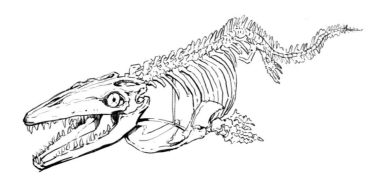

If taking on a complete environment feels intimidating, start by just adding a bit of context to the main subject you're sketching. We can start with the main subject—which is this Mosasaur skeleton.

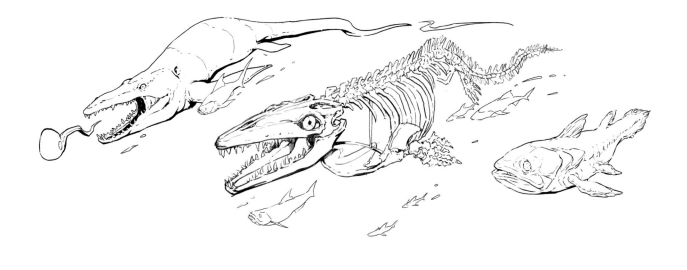

Then I can add some additional elements to add some depth and interest surrounding the subject.

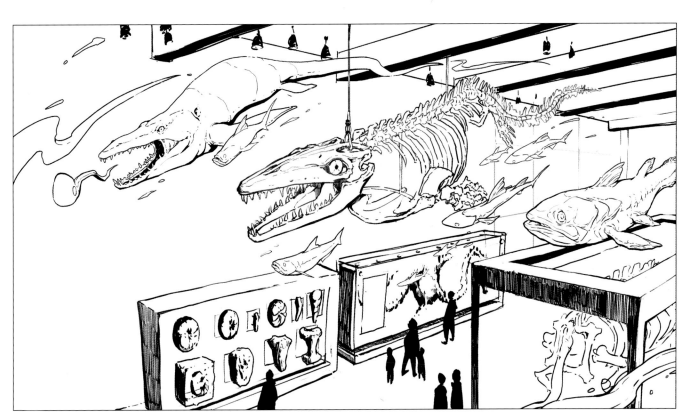

I can go further and add even more context to this image. Now we have a full environment surrounding the subject.

TWO-VALUE STUDIES

Using two values to simplify what we see can also be helpful. Look for interesting shapes not only from the subjects around you but from the way light interacts with thespace. This is easier to see when there's direct sunlight and high contrast.

LIGHT AND SHADOW

Here are some small studies I've done. I'm still loosely thinking in terms of two values, shadows/details and light/negative space. When looking for interesting compositions, I've personally found it more helpful to look for arrangements of light and shadow instead of the objects in the scene.

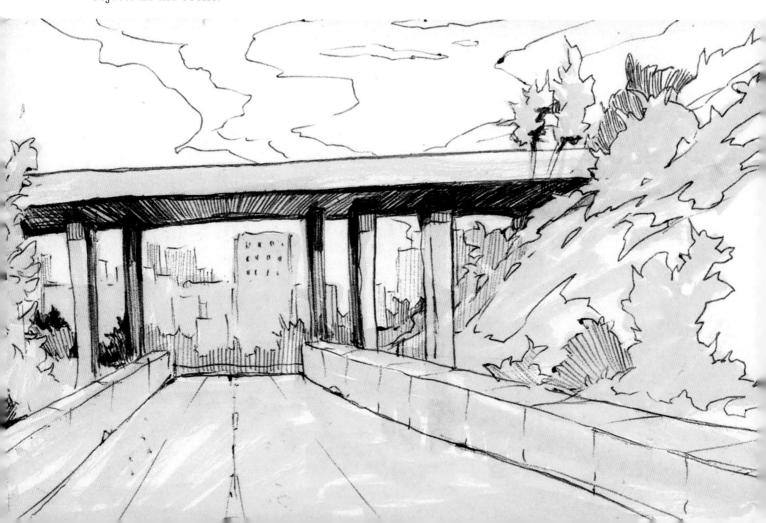

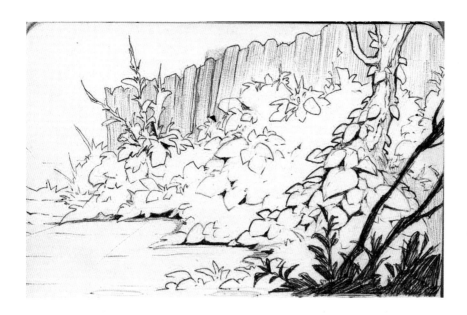

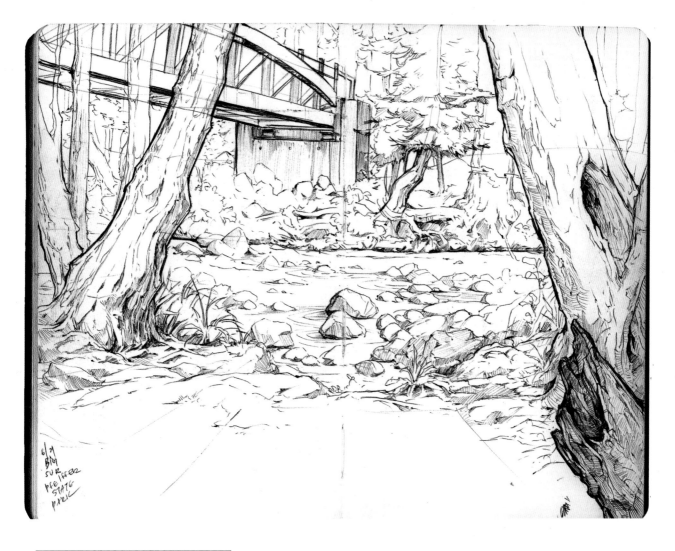

This page was from a trip to Big Sur. I blocked in some loose structure with a blue ballpoint and switched to black to draw details. I had a lot of trouble here in terms of balancing out detail.

TRAVEL SKETCHBOOKS

When I take a trip, I always like to start a new travelers notebook insert. I usually take the watercolor insert, which has about thirty pages to fill.

BACKPACKING

These sketches are from a backpacking trip to Fall Creek Falls, Tennessee, and are done in watercolor, ink, and gouache. Most of these sketches were not finished on location because we were walking continuously.

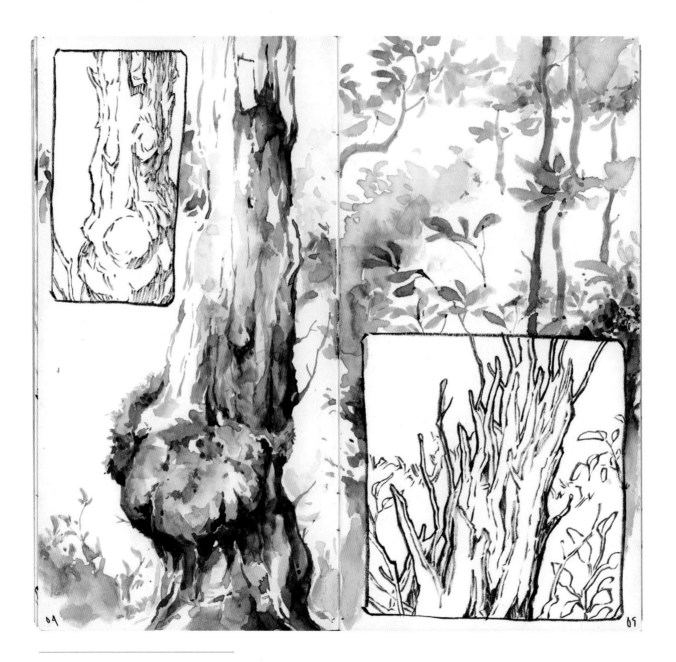

This spread was done with a Pentel brush pen and watercolor.

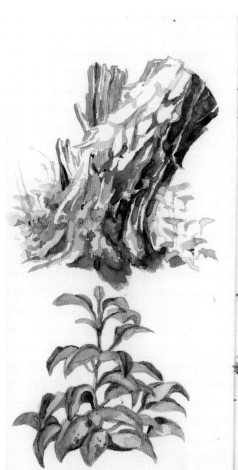

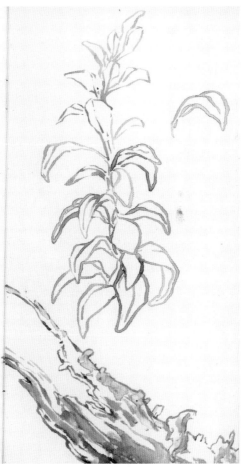

This spread was painted in gouache with a limited palette. I was still getting used to the medium, so I tried out little thumbnails of trees using different color combinations. On the right side, I tried using the paint like I would with a brush pen and only painted certain sections.

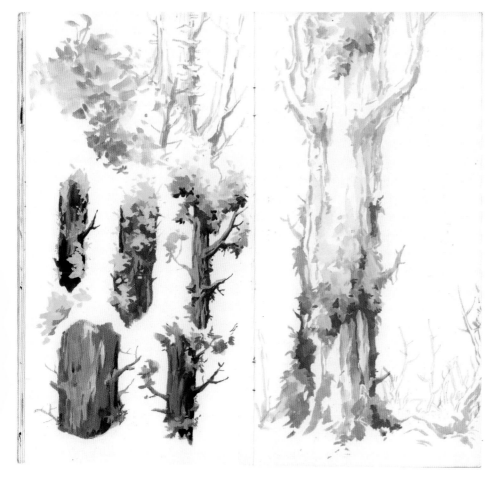

This entire spread was painted in watercolor. On the left side, I tried focusing on light and shadow and carving out the form using negative space. On the right side, I tried using the paint for line work again, but seeing if I could create a gradient-like finish with it.

Before I left on the trip, I went through the sketchbook and drew in some little panels throughout. This forced me to look for compositions that fit those dimensions throughout the trip.

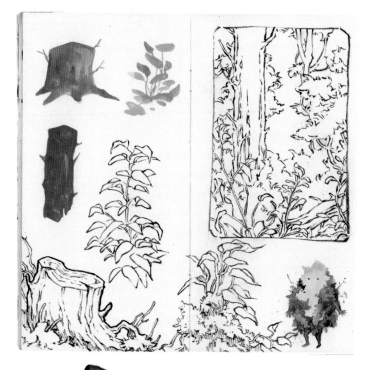

When painting with gouache, I usually start with the silhouette of the subject, as you see on these pages. I use these shapes as the base to add shadow, highlights, and other details slowly to build up dimension. This is also a great way to quickly jot down something from observation when you don't have too much time.

I started the sketch using a Col-Erase pencil on location, and then finished it with colored pencils from photo reference. Using colored pencil takes a lot longer than I'm used to, but I really love being able to build up the colors in layers and layers.

On this spread, I used a Pentel brush pen to draw some trees from direct observation. I grouped shadow shapes, and then added the shadows on the ground plane and in the background from imagination.

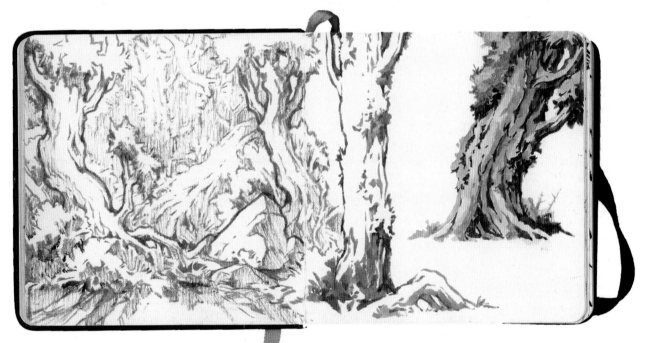

ABOVE: I drew this spread from imagination, using what I had observed for inspiration and information. The left side is ink, and the right is watercolor.

RIGHT: This was an exercise in pushing form. I sketched loose shapes of backpacks in watercolor and filled them in from imagination with ink.

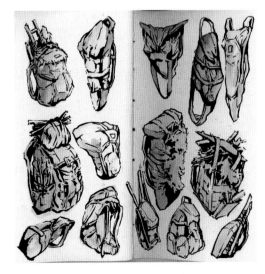

ROAD TRIP

These pages were created on a road trip from Fayetteville, North Carolina, to Los Angeles. They were all painted on location. The main struggle was finding time to draw on the trip, but it was a great experience regardless. In retrospect, I wish I had created many more five- to ten-minute quick sketches along the way.

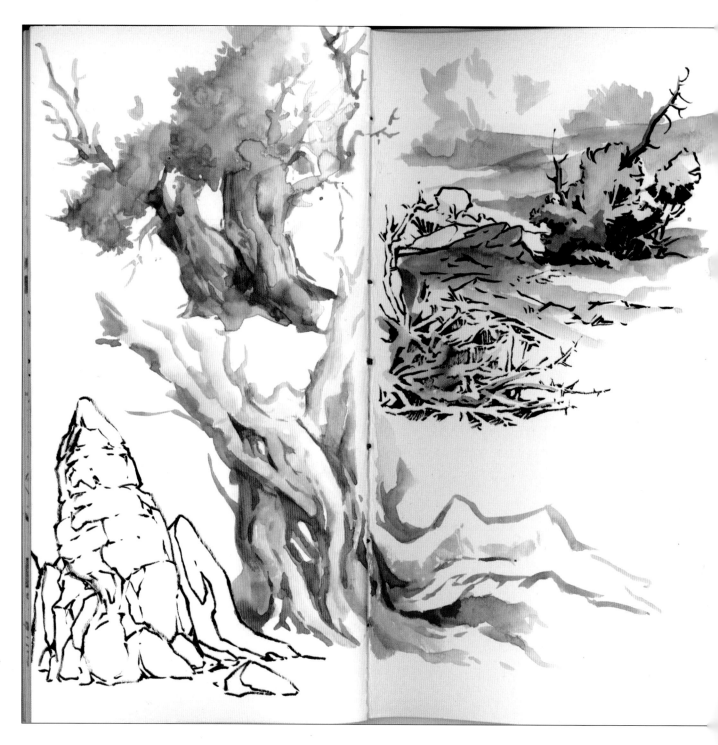

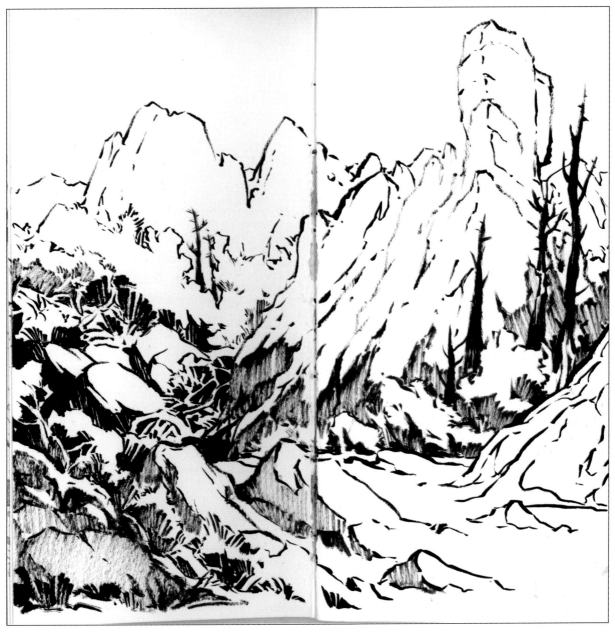

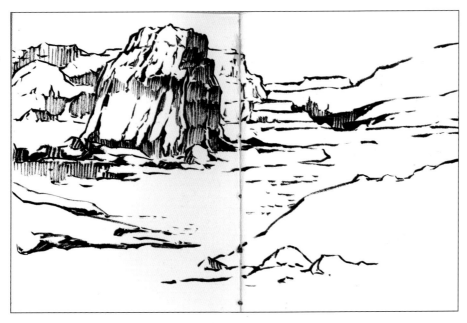

CAFÉ SKETCHING

Here are some sketches from cafés and restaurants. I'll usually do these sketches in little chunks whenever I take breaks from work. Sketching in cafés is a wonderful way to draw people because they are usually sitting still for a period of time, as well as furniture, food, and other props.

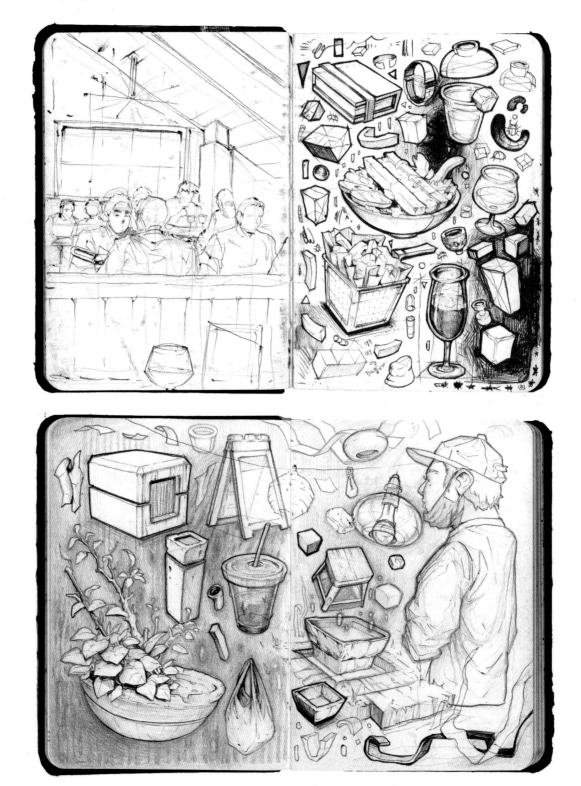

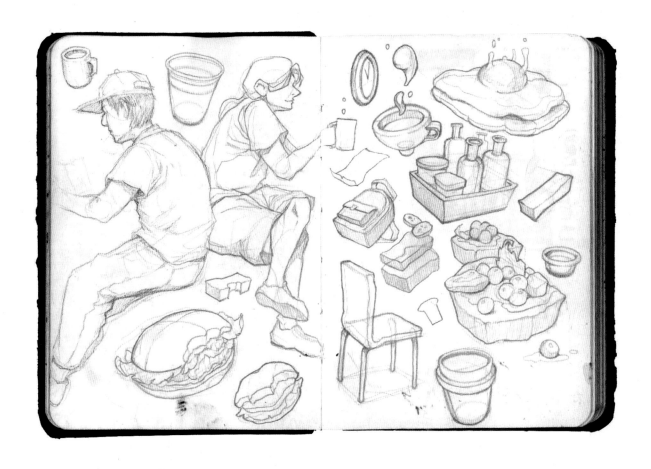

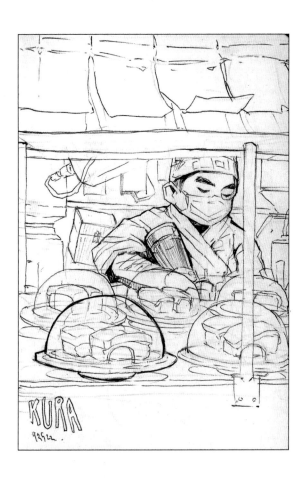

KURA

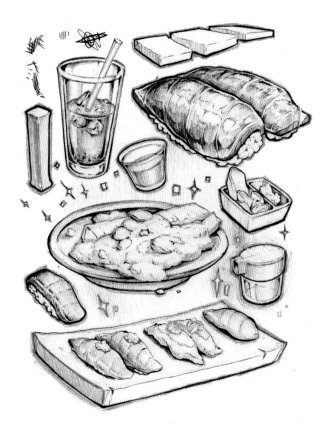

BEYOND OBSERVATION

DRAWING FROM IMAGINATION

Drawing from imagination can be challenging, but with some practice and techniques, it is possible to create compelling artwork from your mind's eye.

Here are some tips on how to draw from imagination:

* Observe the real world: Even when drawing from imagination, it's important to have a strong foundation in drawing from observation. Studying the way objects are shaped, lit, and textured can help you create convincing drawings from your imagination.

* Use reference materials: While you're drawing from your imagination, it can be helpful to use photographs, sketches, or other images as a starting point. These materials can provide inspiration and guidance as you develop your own ideas and concepts.

* Practice drawing from memory: Drawing from memory can help you develop your visual memory and imagination.

* Experiment with different techniques: Try using different techniques such as loose sketching, detailed line work, or painterly strokes to create a range of effects and textures.

* Practice regularly: Like any skill, drawing from imagination takes practice and dedication. Try to set aside time to practice drawing from your imagination and focus on developing your skills and techniques over time.

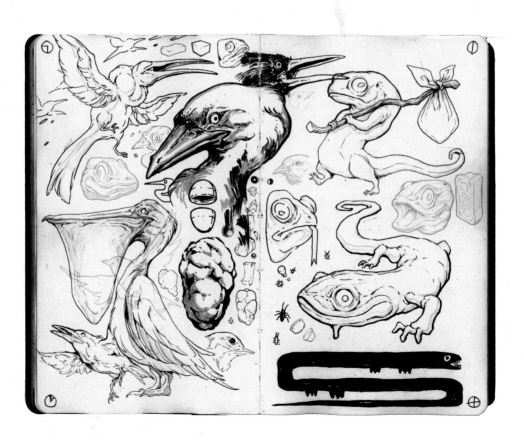

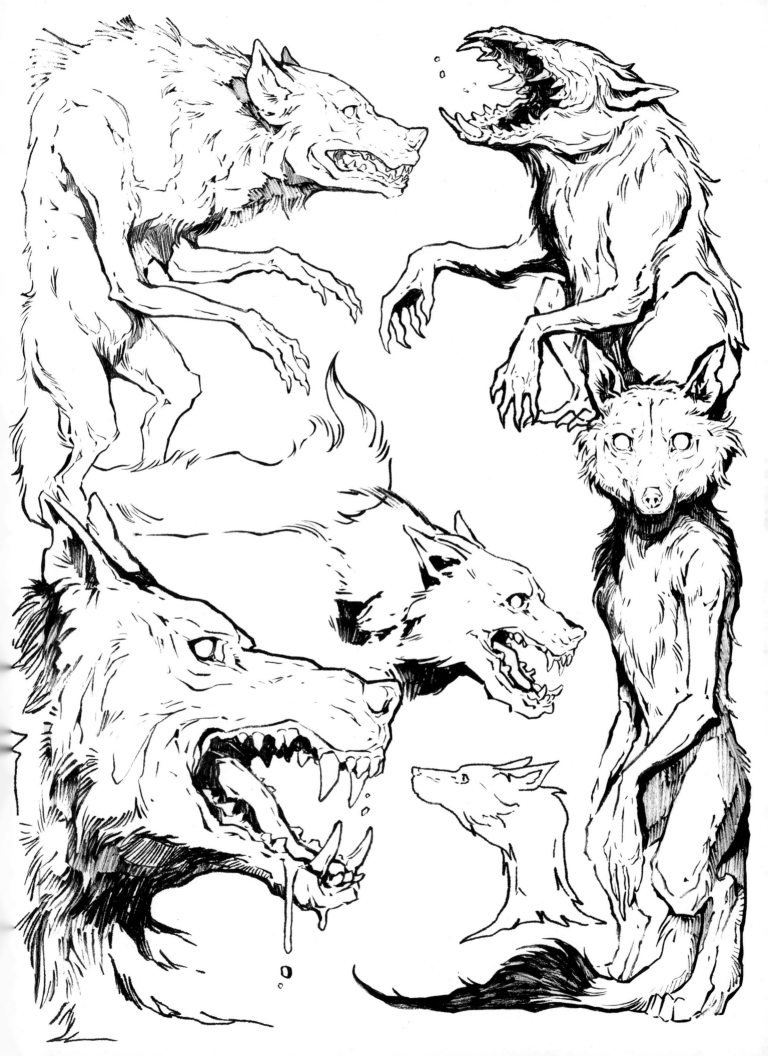

DOODLES

I consider doodling to be one of the most important parts of my creative process. This kind of stream of consciousness drawing feels the most natural and keeps me from overthinking. My mom used to always scribble on something when she was on the phone, and she passed down the habit to me. These pages don't really have any kind of direction or objective behind them. I'm just making fun little shapes. Doodles can be a great way to practice basic forms and rotations in your free time.

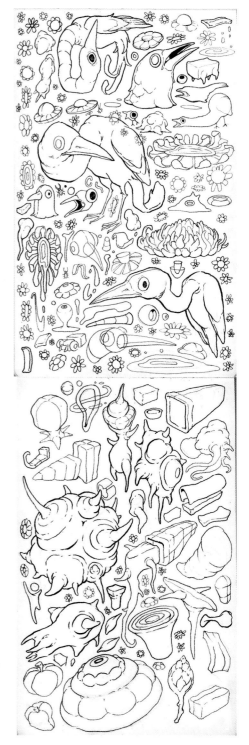

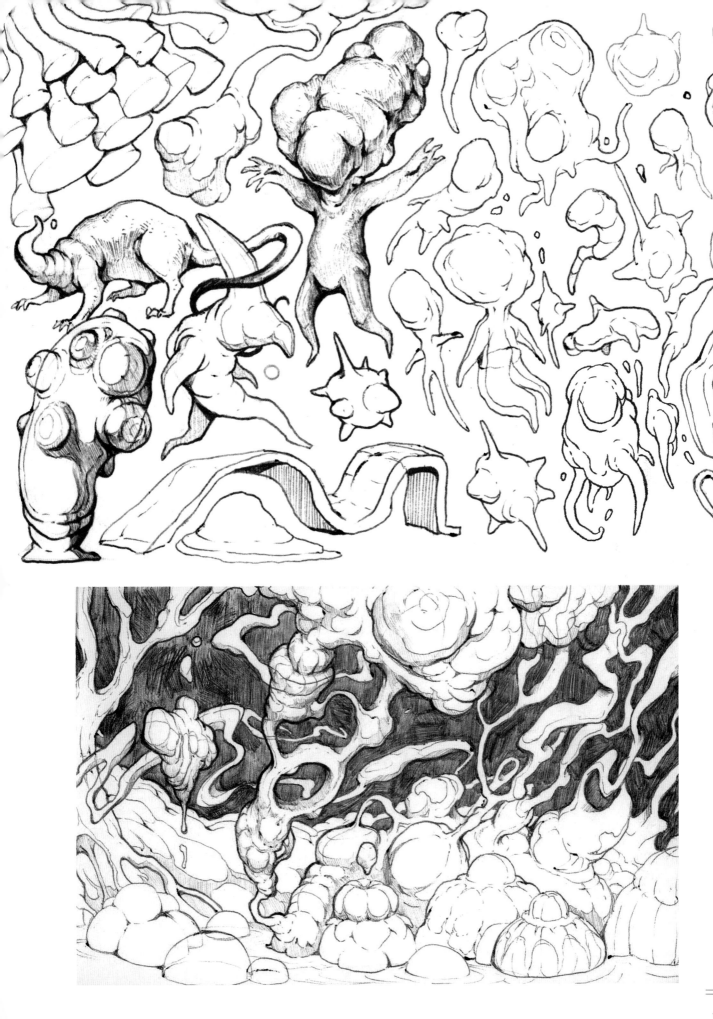

SOLID DRAWING

Lately I've been heavily focused on trying to understand and define volume in what I'm drawing. I'm also trying to familiarize myself with my subject enough that I can manipulate or rotate it freely. In animation, this is called solid drawing. The goal is to be able to create three-dimensional sketches that you can bring to life.

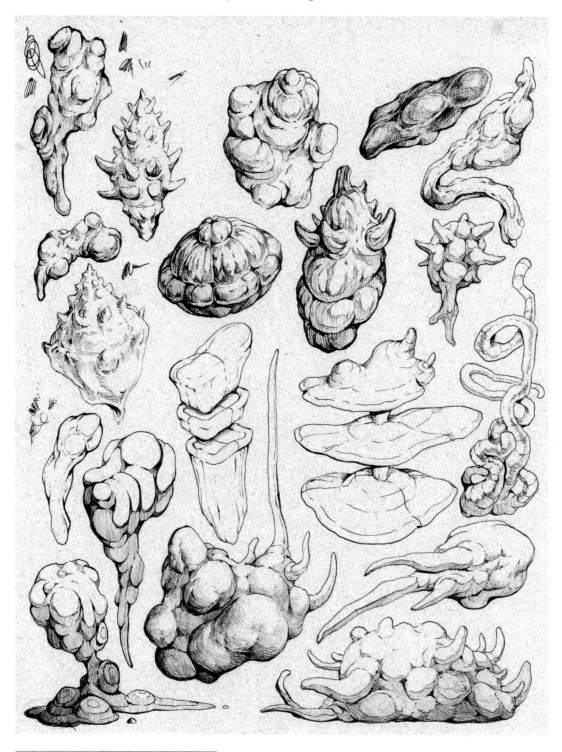

In these pages, I've played with form and practiced solid drawing on a variety of subjects.

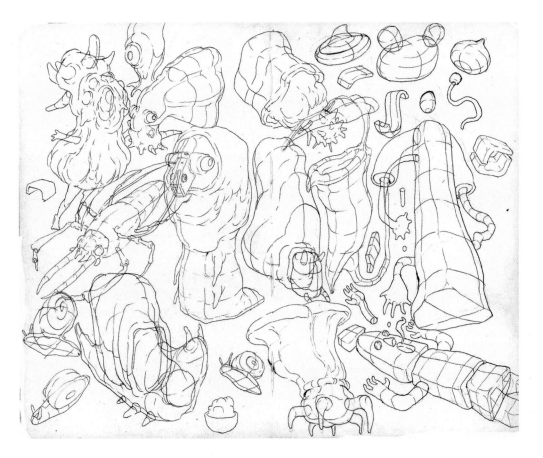

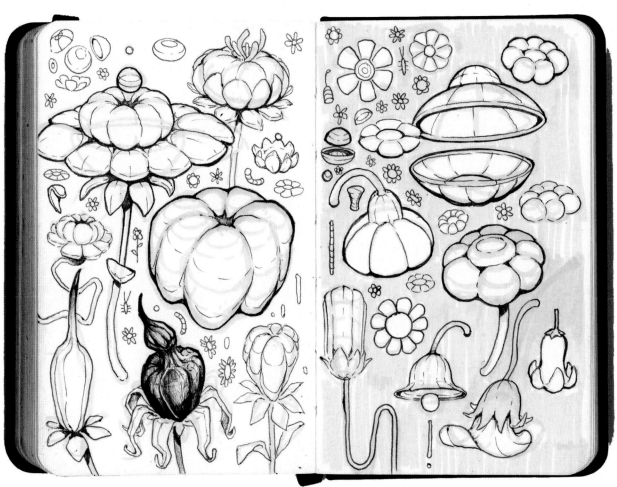

FROM OBSERVATION TO IMAGINATION

As we sketch more and more from observation, we start to retain what we see. Think about building a collection of different shapes, angles, and perspectives in your mind. Then we can also start to design and play with proportions and forms. For example, we can take this tiger and make slight adjustments to the shapes. I still want to keep the subject recognizable, but I'm thinking about ways I can change it.

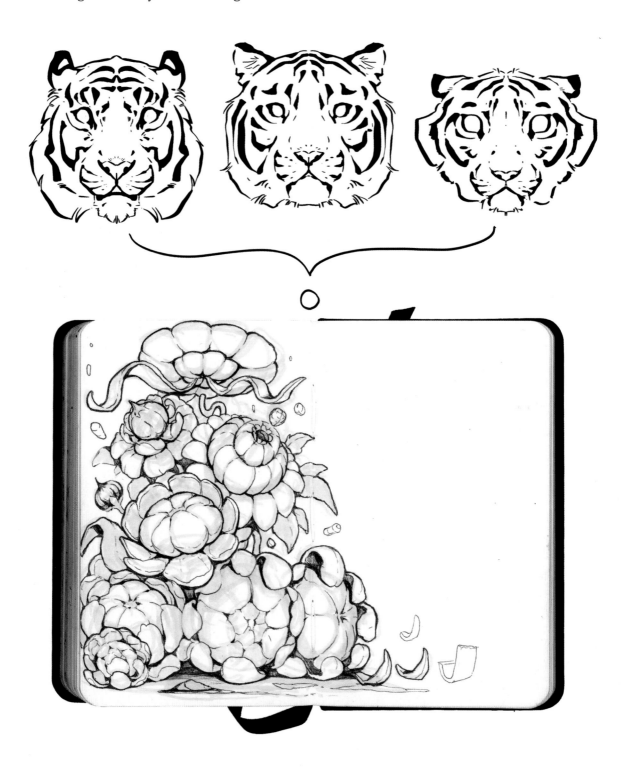

BASIC FORMS

We can take perspective and form from reality, and then redesign. Let's take these studies of fish from the Monterey Bay Aquarium as an example. The first step is construction and simplification. I'm trying to get an understanding of the basic forms, while I also want to greatly simplify. I want to understand all the components of the subject and how they might fit together or turn in space.

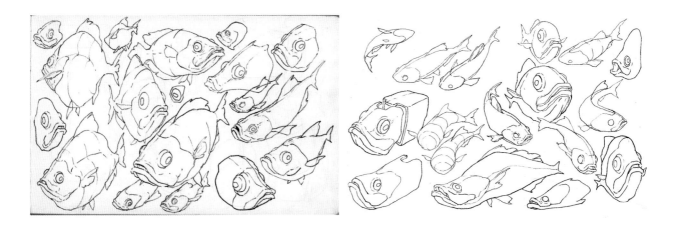

STYLIZATION

I'm referencing the forms I learned from observation, but now I'm attempting to exaggerate or change certain aspects of these fish. My biggest struggle has been trying to maintain the characteristics and volume of whatever I'm drawing, so it helps to practice with simple subjects that I'm already familiar with.

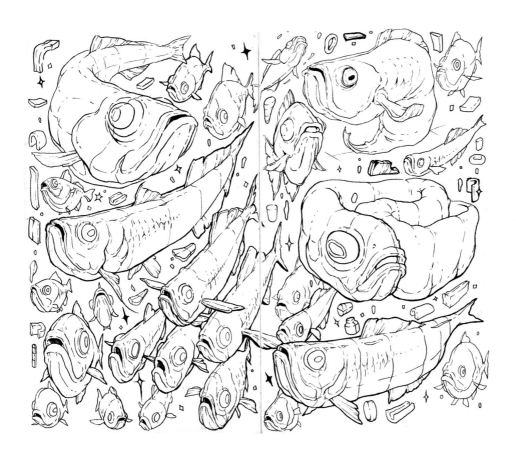

REINTERPRETING SUBJECT MATTER

One way to incorporate elements of imagination into your work is to reinterpret your subject matter while sketching on location.

In this exercise, I am completely changing aspects of the subject and incorporating more elements of imagination. For example, here are some creature heads inspired by different animals. The animals were used as base for structure, but I changed most of the components.

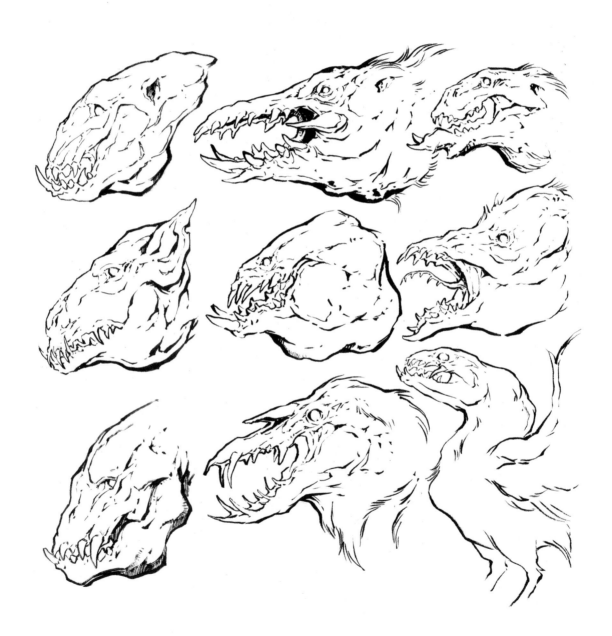

Here are some examples from themed figure drawing. Each week the models dress up in costume. I took the perspective and subjects from observation and incorporated some narrative elements.

A great way to practice sketching from imagination is to begin with slight adjustments to observational sketching. These sketches were based off of a display from a museum. I started out with sketching the subjects, and tried sketching them from different perspectives.

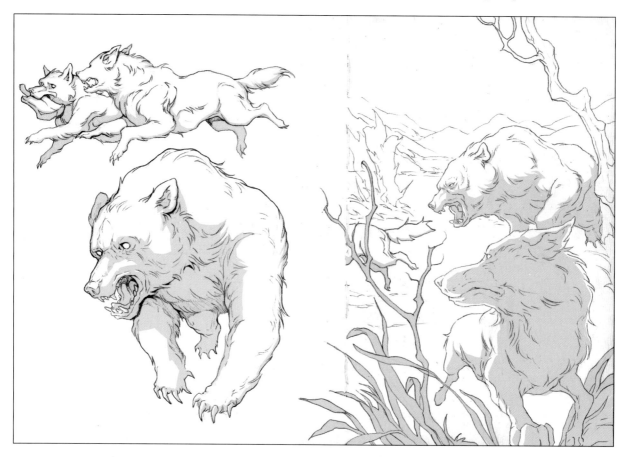

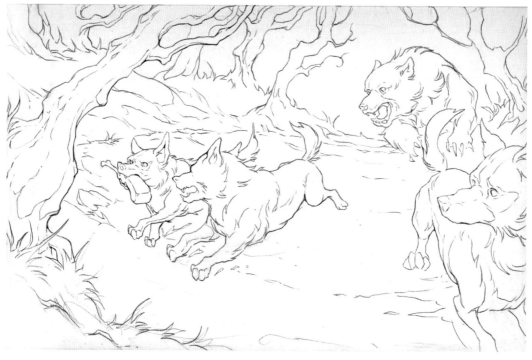

While sketching the bear and wolves at a natural history museum, I invented a storyline and put them in a scene.

Sketching and understanding a variety of subject matter will help in drawing from imagination. For example, when we sketch with a goal of understanding our subjects, we learn how to apply what we learn to our own designs. For example, here are some zombie creatures based on animal skeletons.

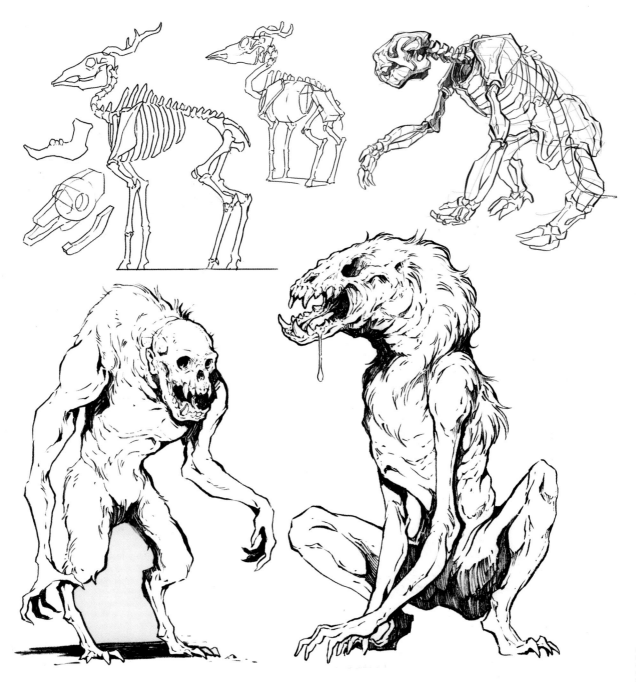

ABSTRACTION

Just because we're drawing from direct observation doesn't mean the sketches always have to be representational. We can incorporate elements of abstraction and stylization to make our interpretations more interesting.

Abstraction in art refers to a departure from realistic representation. We can distort, simplify, or exaggerate forms to create a more subjective or expressive work. This approach allows you to convey ideas or concepts that may be difficult to express through purely realistic representation.

Here are some examples of taking a more abstract approach to sketching a flower.

Here are some abstract interpretations I drew of some sunflowers.

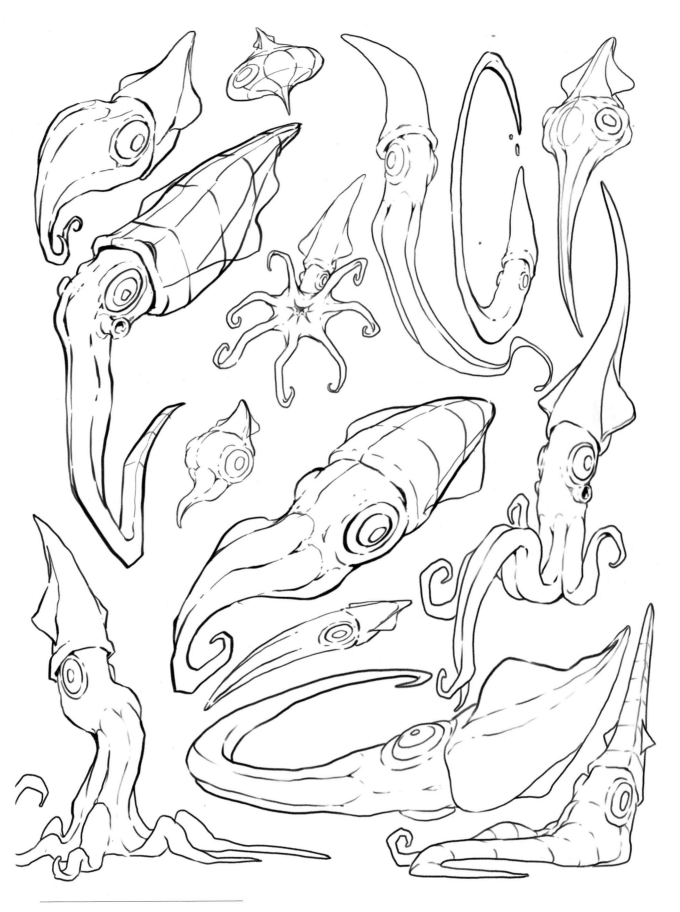

Here I played with sketches of squid, simplifying them, adding personality, and creating fun shapes.

GATHERING ADDITIONAL REFERENCES

Drawing from direct observation is a great way to learn sketching, but remember that you aren't limited to the resources and references directly around you. Naturally some ideas and concepts will require other references, and you can supplement what you see directly with books, the Internet, and all kinds of other media.

SUPPLEMENTING OBSERVATION

Today we're able to look through historical images, artwork, films, and other media that we don't have direct access to, so take full advantage of all the resources around you.

If you started a sketch from life, you can supplement it with references to further help you understand its form and details. Try to compile references from various angles to inform your studies. It can also be helpful to reference videos to take a look at movement.

MASTER STUDIES

Master studies are also a great way to improve your craft. Look at films, games, and art that inspire you and copy them. Instead of getting too wrapped up in replicating the piece perfectly, analyze what you like about the piece or the artist, and break down those specific components to bring them into your own work.

CREATING REFERENCES

You can also start building your personal reference library by taking your own photos. This allows you to capture the exact angles, lighting, and details that you need for your artwork.

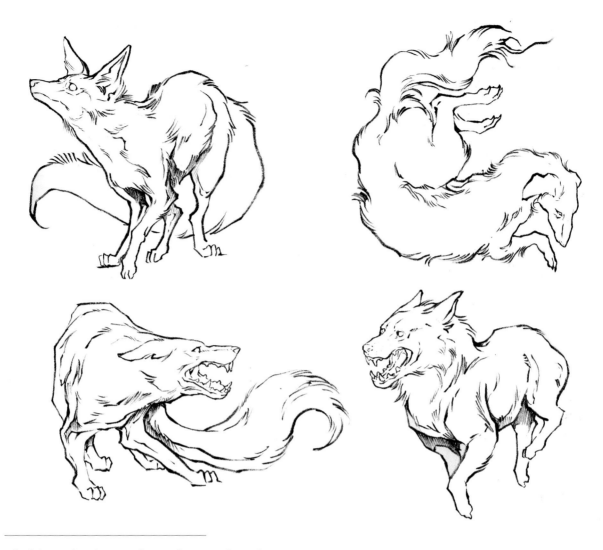

All of these sketches are from references from the Internet.

A Note on Copying

While using additional references in art can be helpful, make sure that you're using them ethically and appropriately. This means being mindful of copyright laws, being respectful toward other artists, and avoiding plagiarism. Use a variety of references to avoid relying too heavily on a single source, and think of your references as guides rather than copying them verbatim.

OUTSIDE THE SKETCHBOOK

Your sketchbook is a place to explore and experiment, and it's often where some of your best ideas will originate. Once you have an idea that you're excited about, you get to explore different ways to develop and expand upon it.

For example, I started with these bird designs from my sketchbook that I created at natural history museum. Although I was looking at the birds from life, I was trying to redesign them and explore different proportions and shapes.

I scanned the page and colored it digitally on Photoshop, keeping the colors flat and using simple shadows to just indicate form.

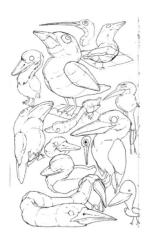

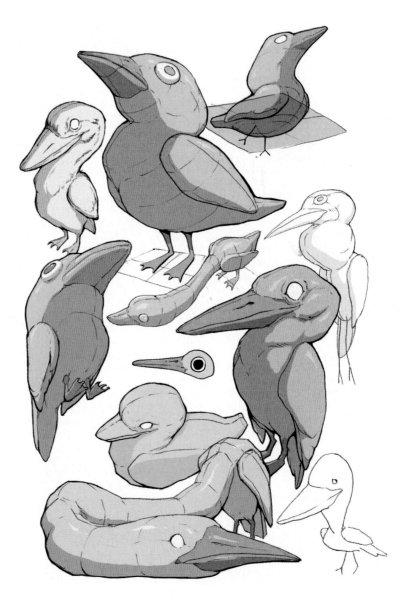

From there, I wanted to take one of these birds and make a character turn around. I realized I had to simplify, so I took off the wings and legs and landed on something that looks like a rubber duck. Not the most interesting design, but I went with something that I felt like I could try to rotate.

The final turnaround breaks down into eight shots: front, two sides, two three-quarter views, two three-quarter backs, and back. I started with line work and added color and shadow.

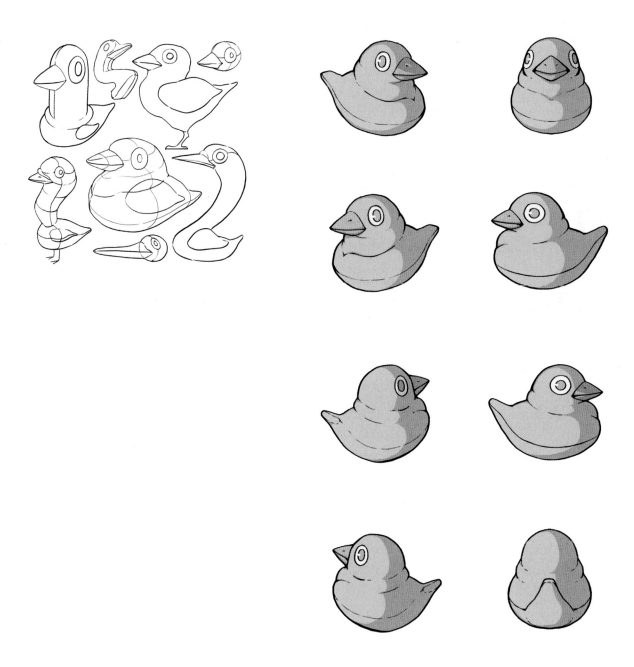

FINAL NOTES

Thank you so much for spending time with this book.

Sketching is a skill that you will develop over time with a lot of practice and patience. The techniques and principles outlined in this book were designed to help you build a strong foundation in drawing, from understanding perspective and proportions to exploring different mediums and styles. I know we've talked a lot about fundamental skills in this book, but at the end of the day, they're not a requirement to make what you want.

You can express yourself and just have fun without any technical knowledge of art or design. The most interesting thing about art is the creative experience and getting to know your own point of view.

If you really enjoy the technical aspects of art—by all means, dive in and study as much as you want. I personally find it really fun, and the more you learn your craft, the more it will bring you freedom and creative control.

If all of this feels overwhelming, or if it's just not relevant to what you want to make, then that's okay, too.

Either way, don't wait till you've mastered the fundamentals to start thinking about what you want to create. Take time to get to know your own creative process, figure out what you want to create, and reverse-engineer from there. You'll learn what you need to along the way.

Whether you're a beginner or an experienced artist, remember there will always be something new to discover and explore. There's no finish line. Keep drawing, keep practicing, and keep seeking out new challenges and opportunities for growth. I hope this book has inspired you to go outside and draw just for yourself.

Thanks for being here.

Go draw.
Have fun.

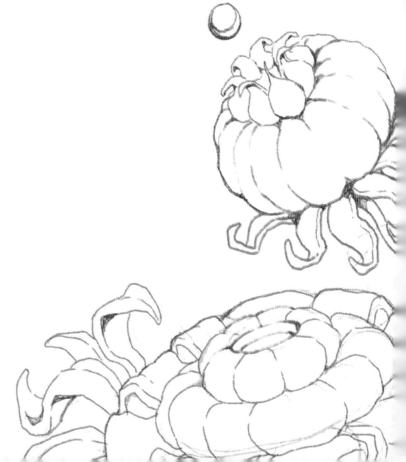

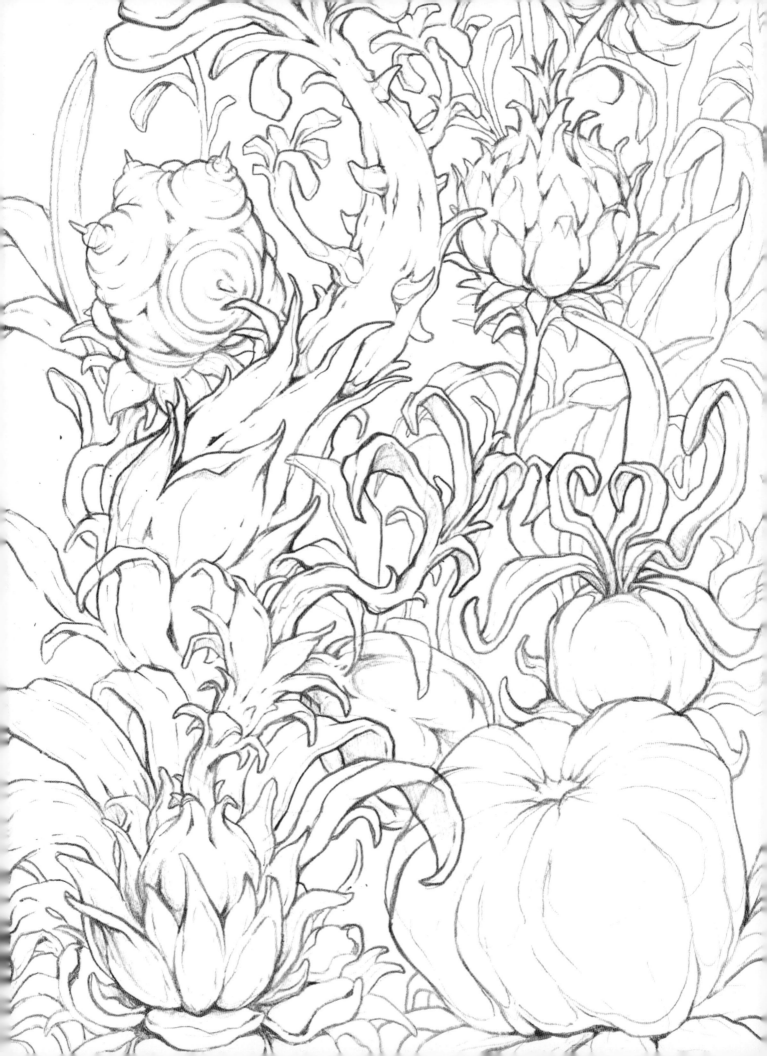

ACKNOWLEDGMENTS

Thank you so much to my wonderful editor, Michelle Bredeson, who walked me through this entire process from the beginning.

Thank you to Marissa Mikolaities, Brooke Pelletier, and the team at Quarto for all the help with this book. I couldn't have done this without you all!

I also want to thank every single one of my students. Becoming a teacher completely transformed my creative process and perspective in the best way possible, and it's all thanks to you guys. I thought of y'all a lot while I was writing this book!

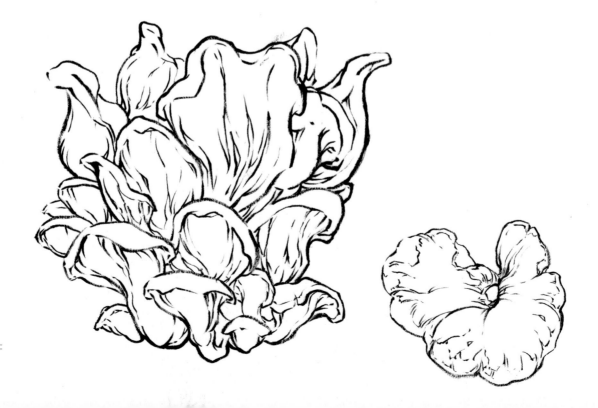

ABOUT THE AUTHOR

Sorie Kim is a Los Angeles–based artist and instructor. She has taught courses and workshops for Domestika, Covenant House California, Create Now, Dreamworks Animation, and many other schools and organizations. Her personal work predominantly centers around observations and interpretations of the natural world, and keeping a sketchbook is an integral part of her personal practice. She has shown her work through Giant Robot, WOW x WOW, and Gallery Nucleus.

INDEX

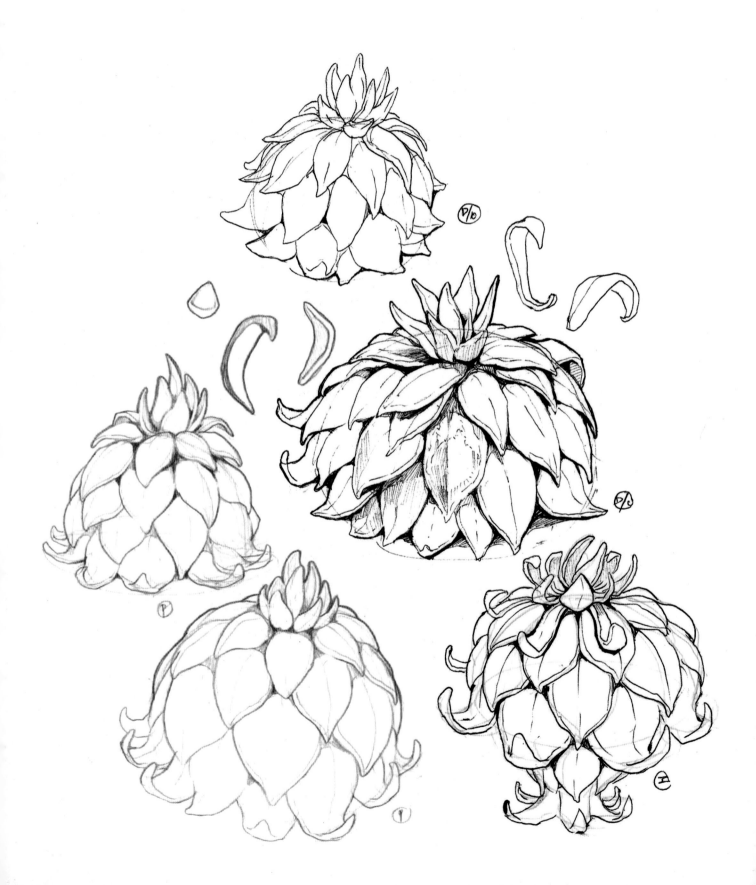